D0307252

CANCELLED

men in this *town*

Alone In A *Crowd*

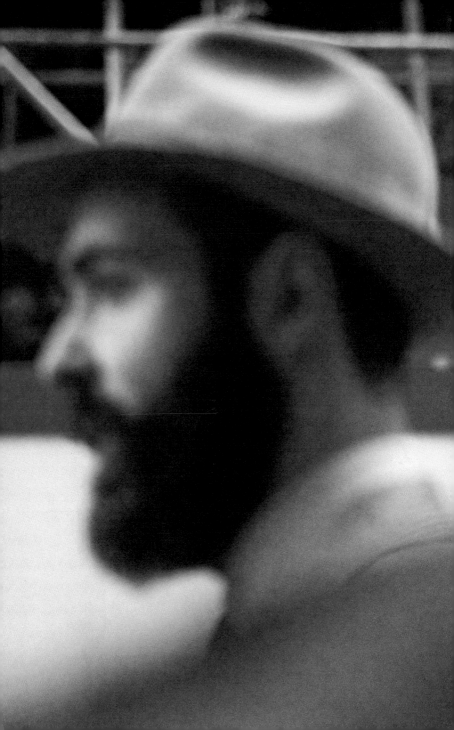

men in this *town*

Alone In A *Crowd*

Giuseppe Santamaria

hardie grant books

To my nephew, Easton.

Contents

TWO THOUSAND FIFTEEN

TWO THOUSAND SIXTEEN

Alone In A *Crowd*

I began the *men in this town* photographic series as a blog in 2010. My goal was to document the way men are expressing themselves through fashion on the streets of Sydney and beyond in this day and age.

I've since travelled the world to capture men's style; my journeys have brought me to New York, Florence, Paris, Melbourne, London, Tokyo and Toronto.

Besides collecting Chet Baker vinyls in each city, I accumulated thousands of men's street-style photos. Some are of menswear enthusiasts outside the fashion week shows, many are of everyday men just walking down the street.

Regardless of the setting, my approach has always been that of the outsider looking in, observing a particular quality about these men's personal style and about the way they carry themselves around as they go about their lives.

Alone In A Crowd spans my travels from 2014 to 2016, beginning in New York and ending in Toronto, the town where I grew up.

Giuseppe Santamaria

Two
Thousand
Fourteen

CHAPTER
ONE

TOWN
NEW YORK

BRIEF
NYFW & THE STREETS

DATE
FEBRUARY 2014

Funk In
Deep Freeze

The first time I attended a fashion week was in February 2011 in New York. Tumblr had invited twenty or so bloggers from around the world to help cover the fashion madness. As wonderful as it was to be invited backstage or to meet top American designers (such as Oscar de la Renta), it was the street style that got me excited.

February 2014 was my fifth season attending. It was a crazy cold week, yet it didn't stop the men of New York from bringing out their best.

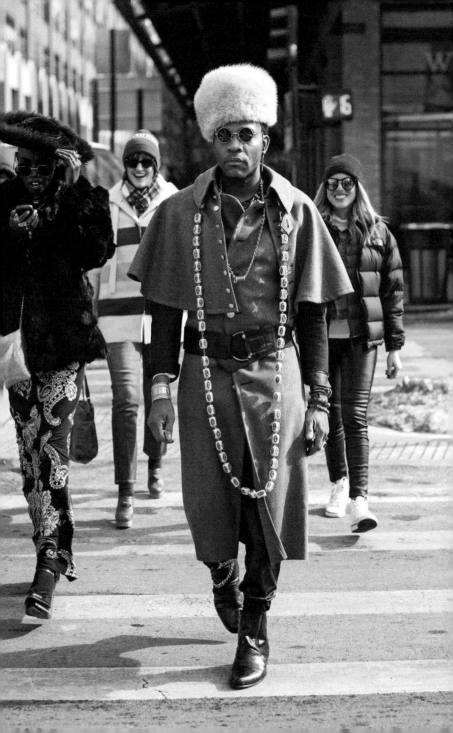

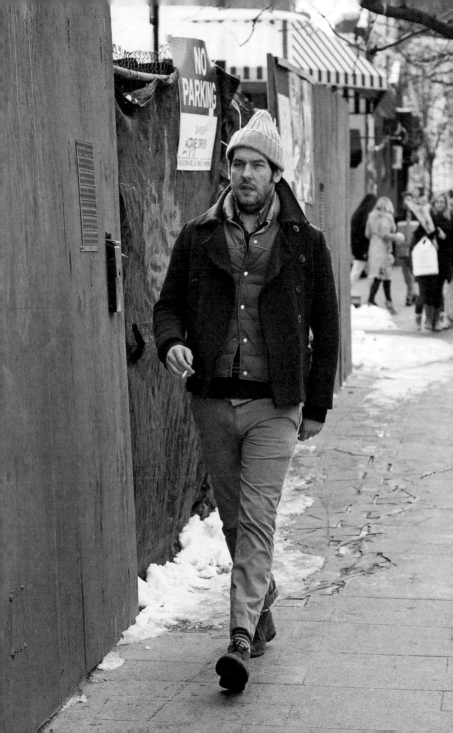

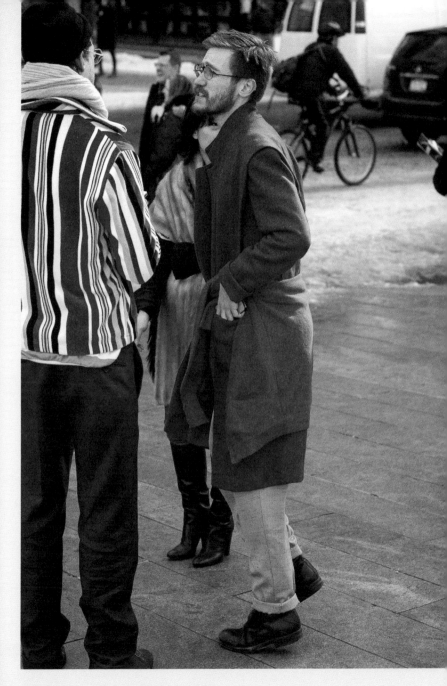

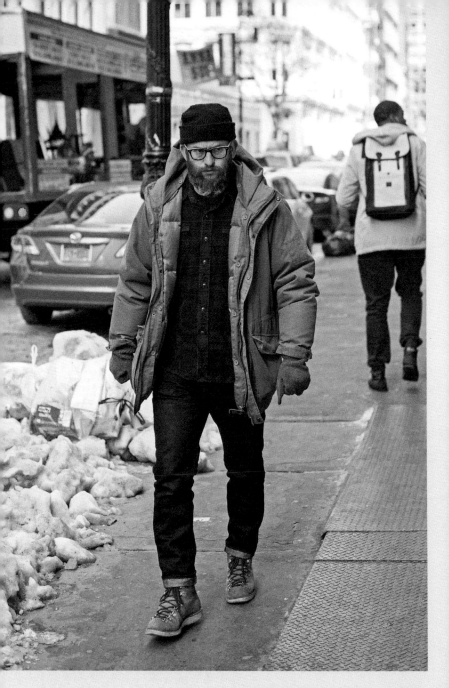

URBAN PLAID · NECK DETAIL ›

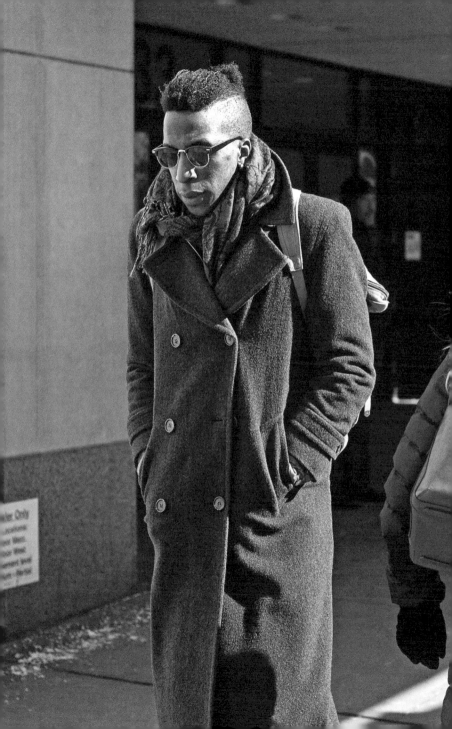

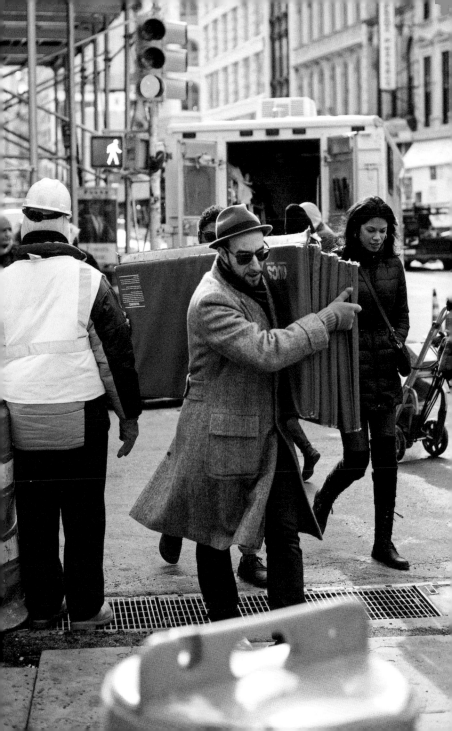

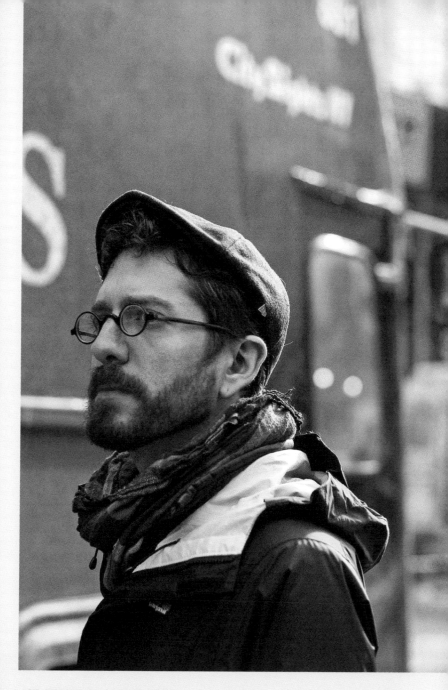

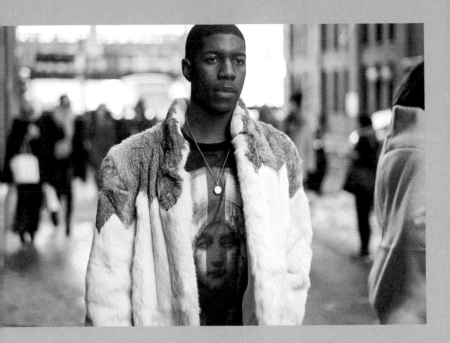

Agree or disagree –
men and women embrace
the warmth of fur on
the streets.

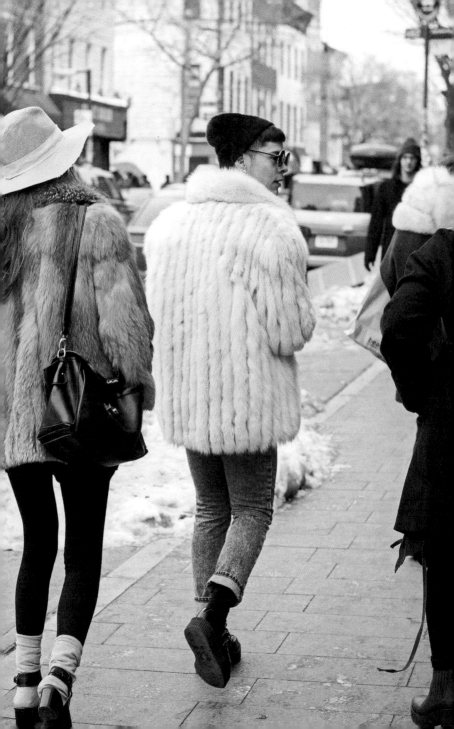

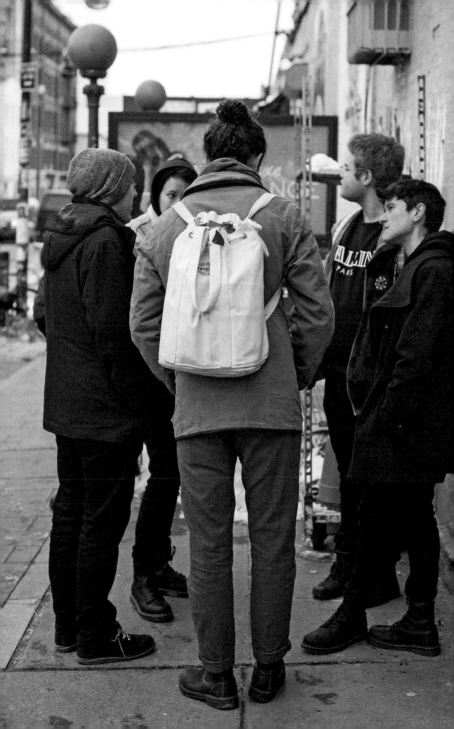

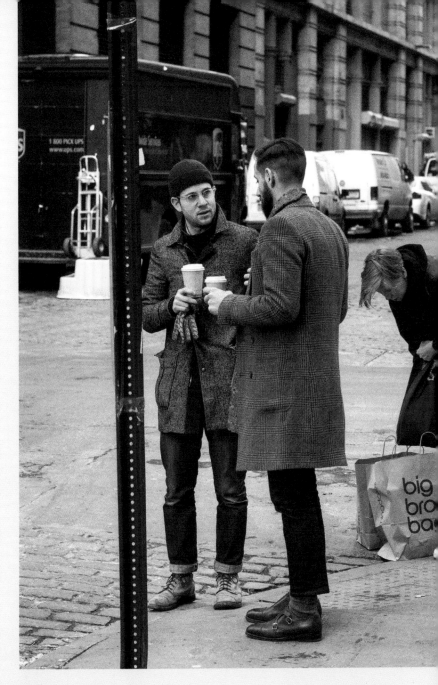

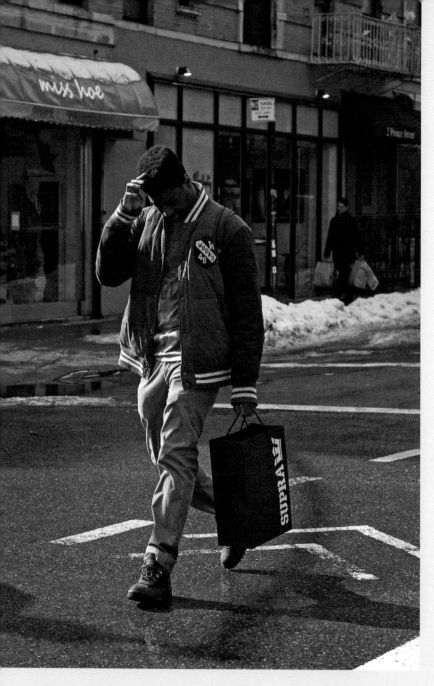

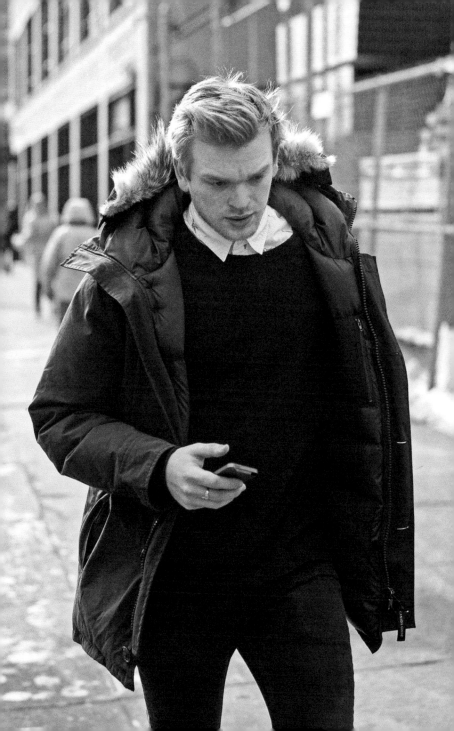

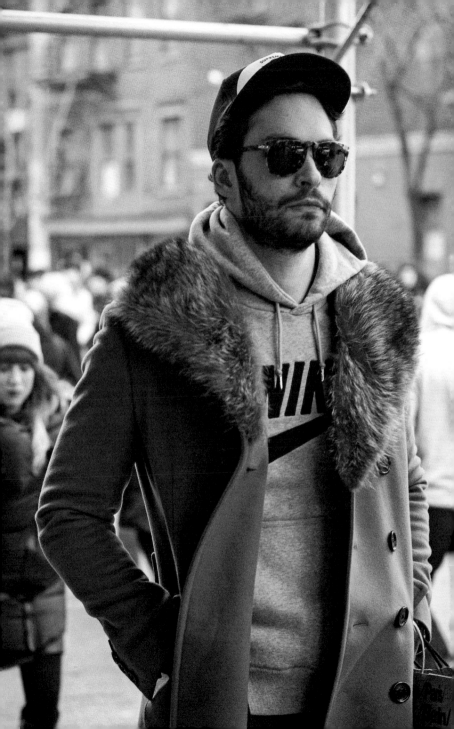

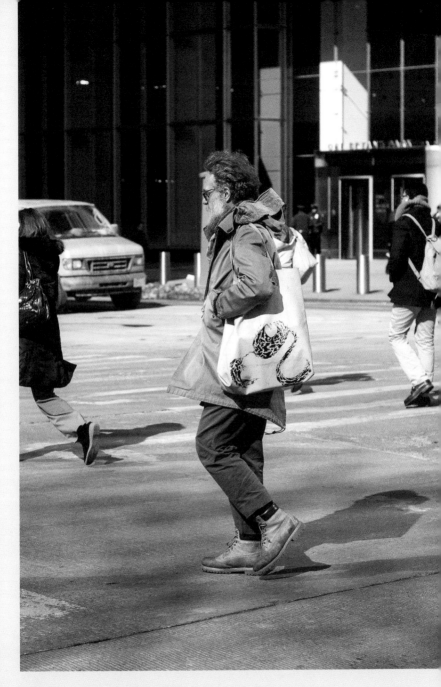

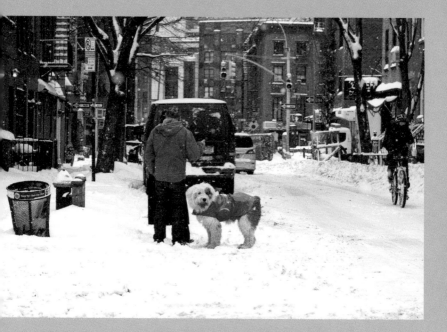

Sidekicks in training,
the future looks bright.

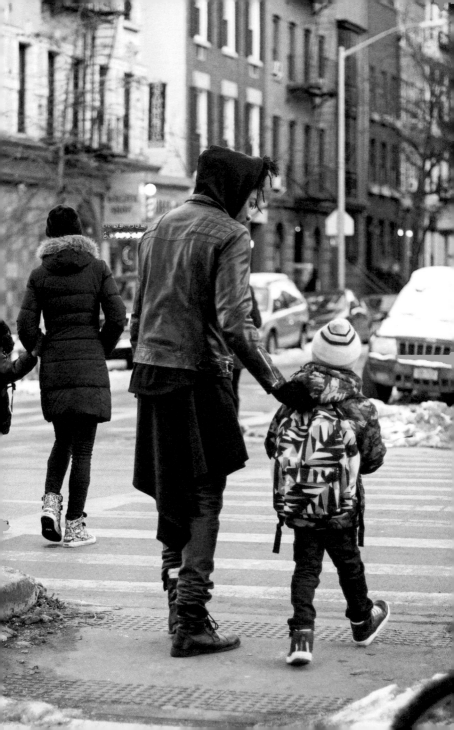

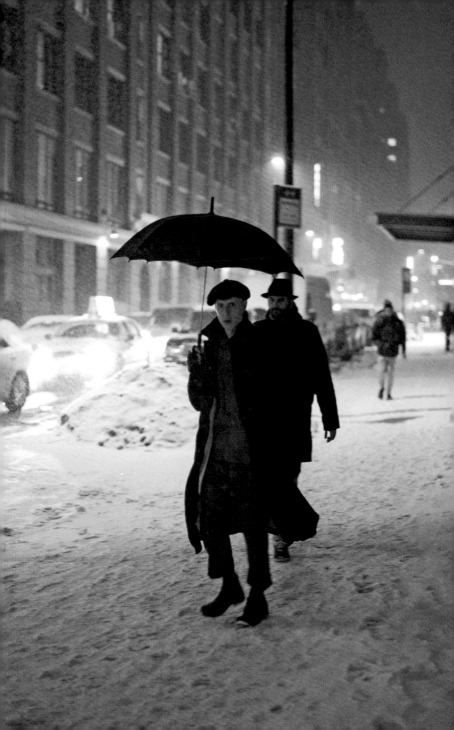

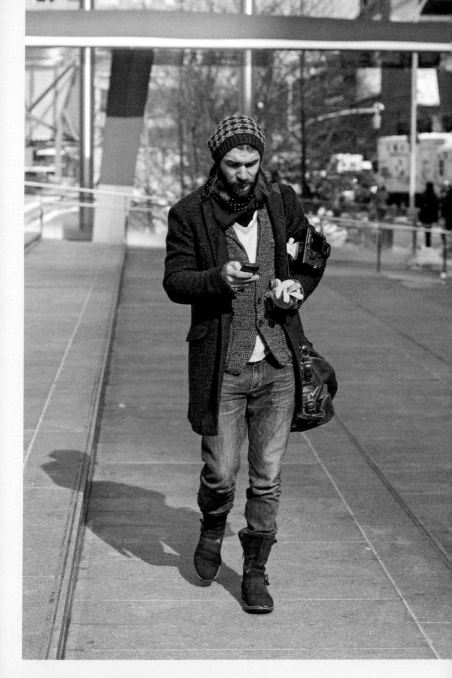

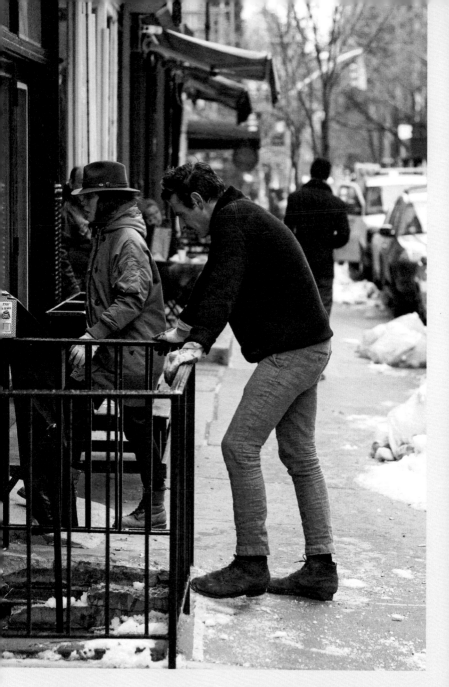

REST STOP ~ WOOL AND FLEECE ›

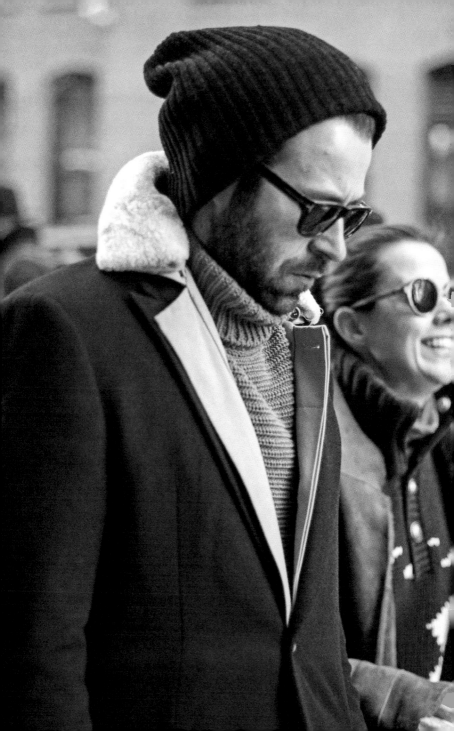

Come Rain or *Come Shine*

After New York Fashion Week, I always look forward to returning to Sydney. Walking familiar streets without the worry of getting frostbite is a comfort in itself, but it's the contrast in styles, sunlight and sights that gives me a new perspective of my home base.

The start of the Australian Fashion Week soon after elevates the more reserved style I tend to capture on the streets of Sydney – and with each passing year, the more flamboyant looks of fashion week seem to remain on the streets longer, lasting well beyond the event. An exciting step for menswear in Australia.

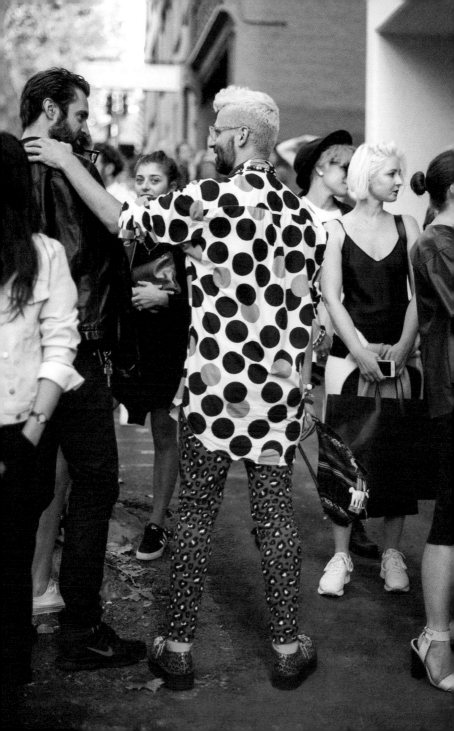

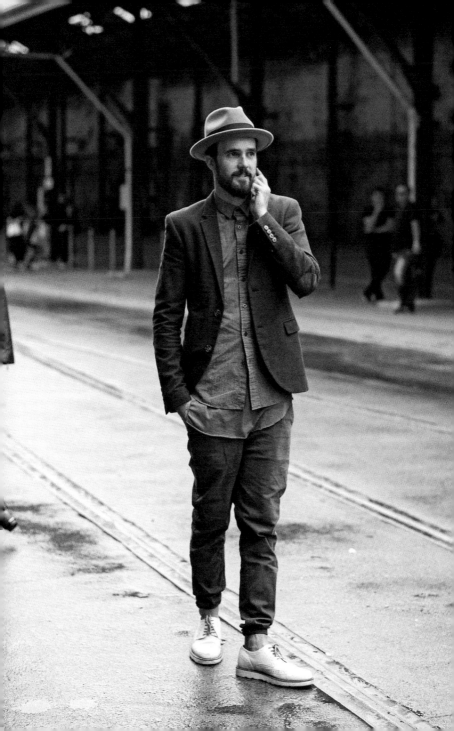

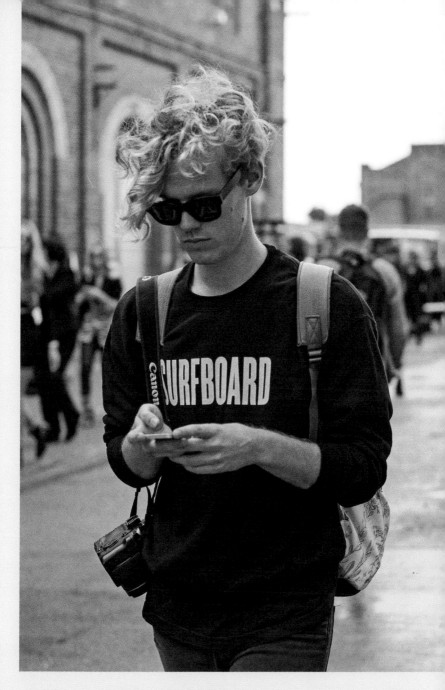

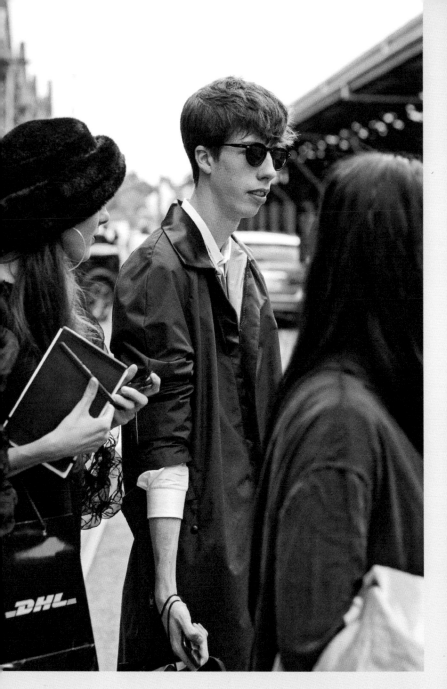

PURPLE ^ RIBBED ›

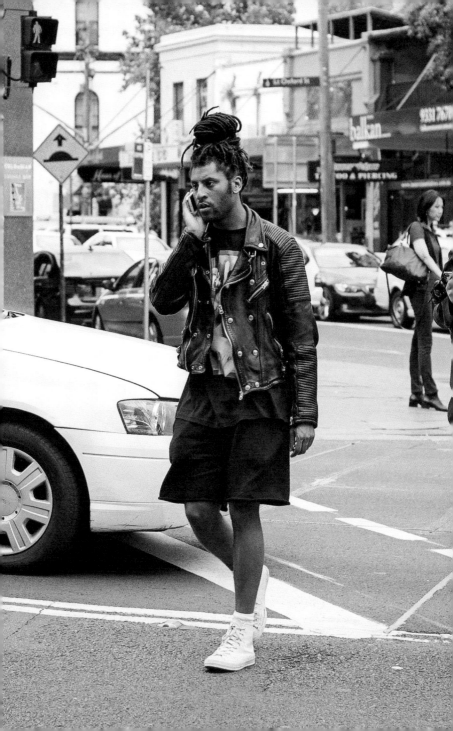

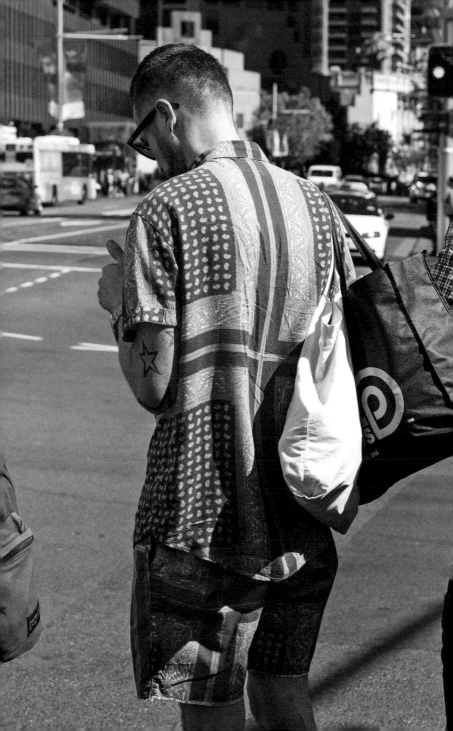

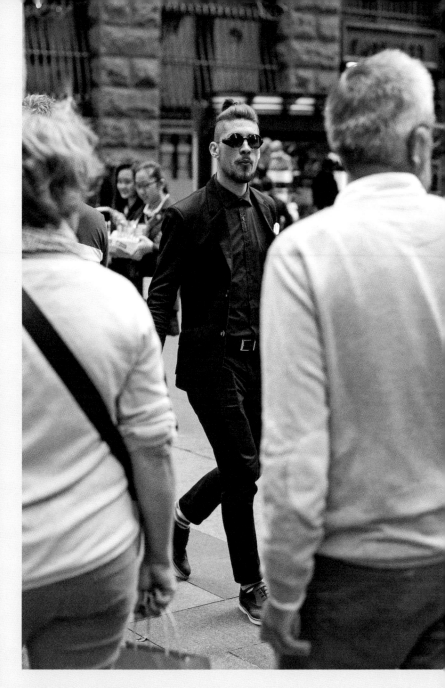

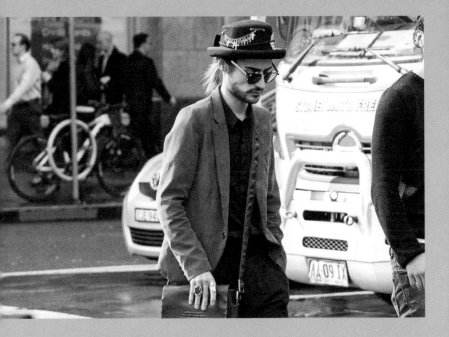

Blurred lines: street style on George Street; impressions from Carriageworks during fashion week.

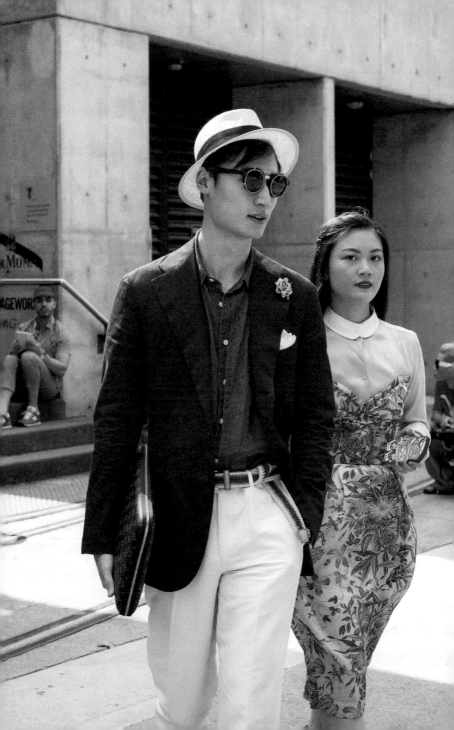

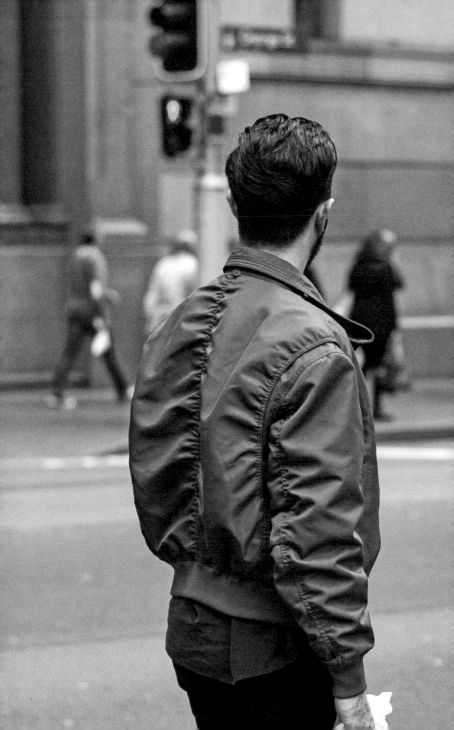

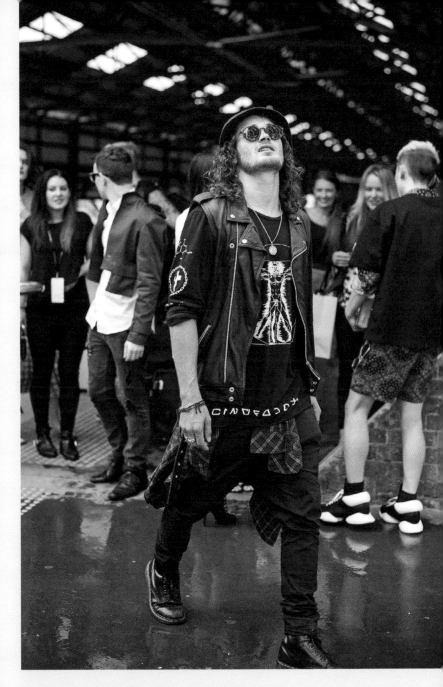

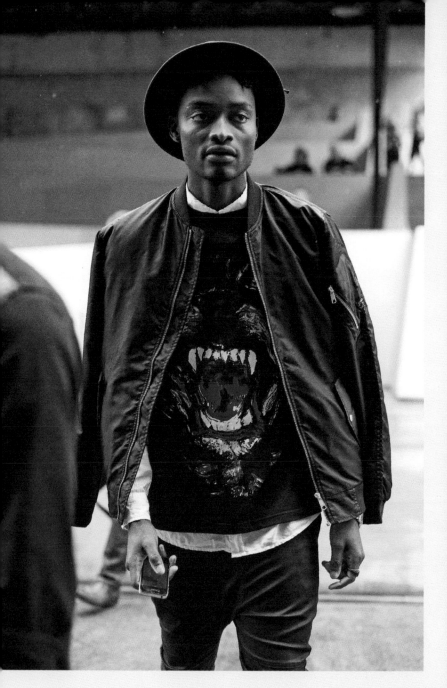

WILD ^ BRIM ›

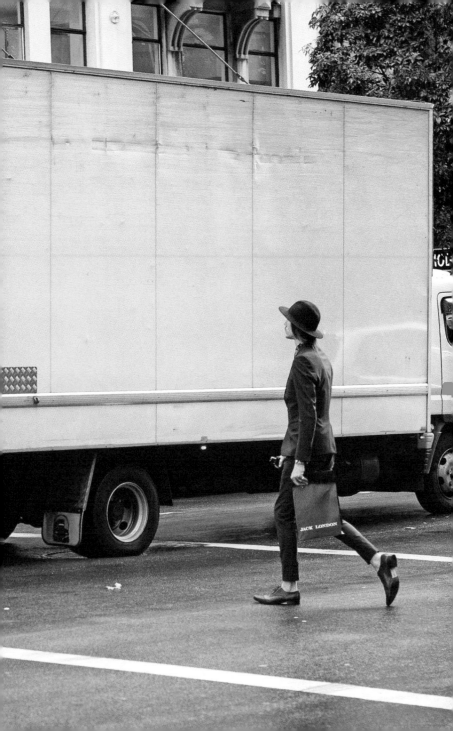

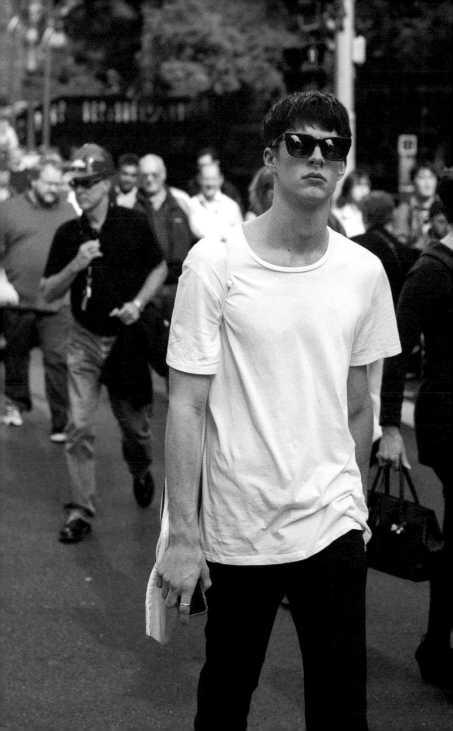

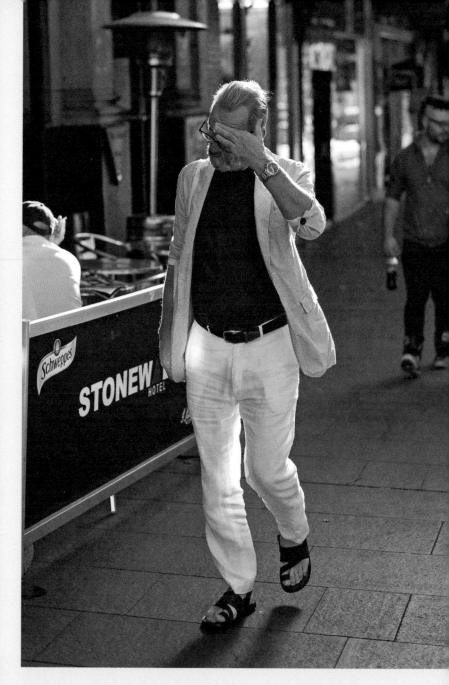

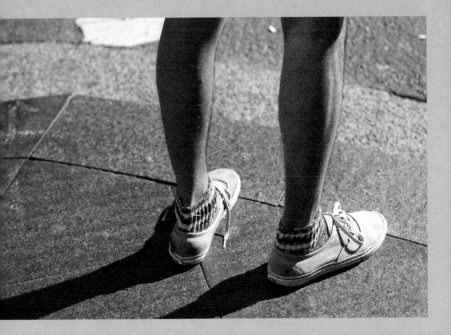

Urban cowboy among the wild and funky.

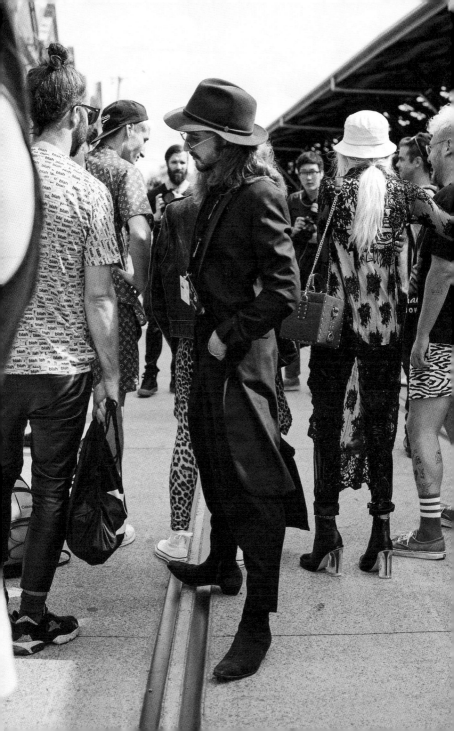

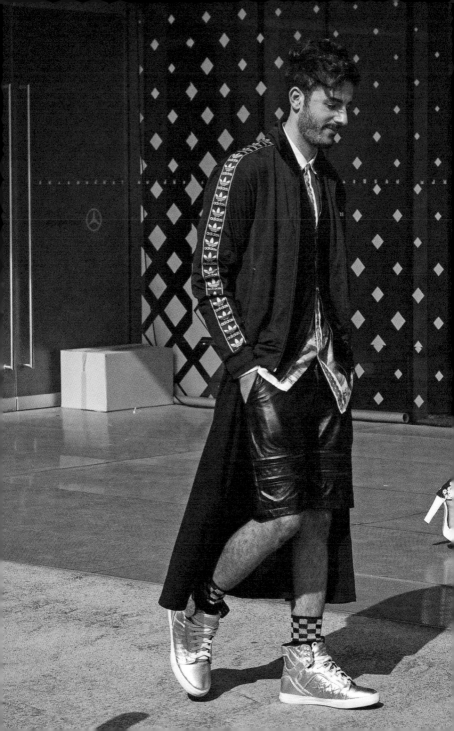

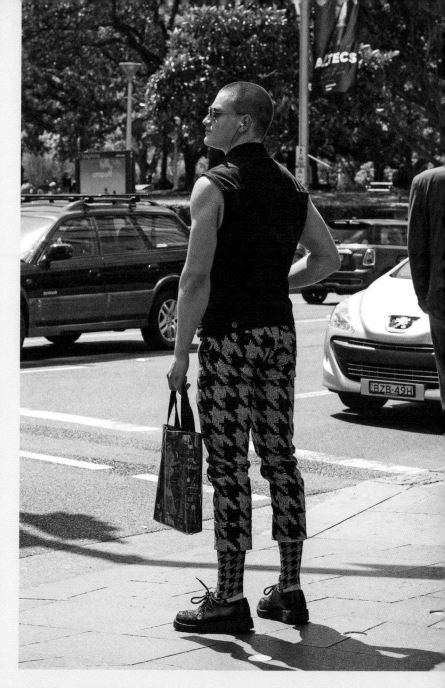

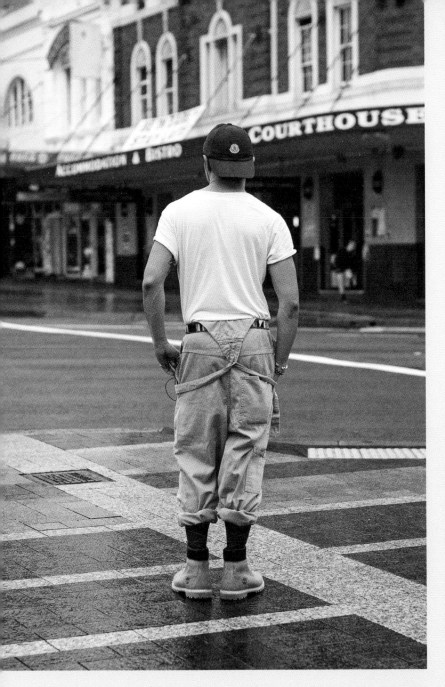

ROLL 'EM UP ^ FLOWER POWER ›

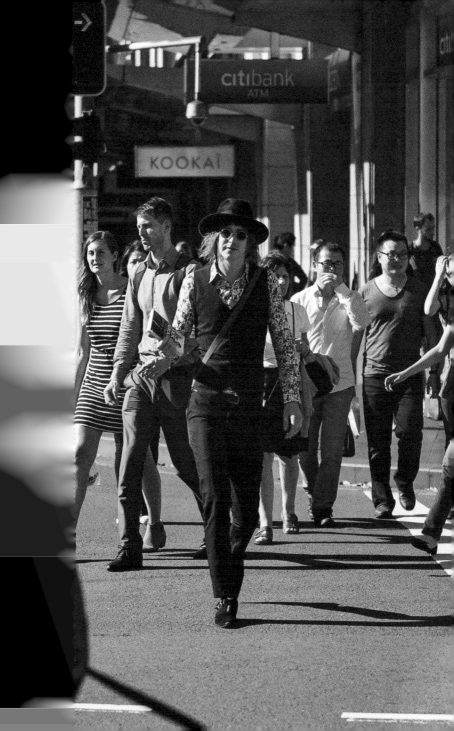

CHAPTER
THREE

TOWNS
LONDON & FLORENCE

BRIEF
LC:M & PITTI UOMO

DATE
JUNE 2014

Polka Dots &
Moonbeams

London Collections: Men and Florence's Pitti Uomo have become renowned for the resplendent looks men bring to the streets. Naturally, they were on my bucket list of events to photograph, so I made my first visit to both in June.

The first half of this chapter showcases the contemporary urban looks I captured in London, the second the traditional sartorial styles of Florence. During this time, I witnessed first hand where the hashtag #menswear was coined.

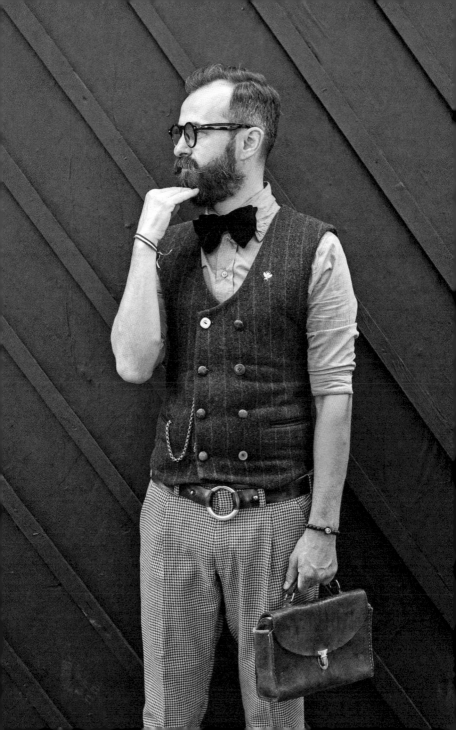

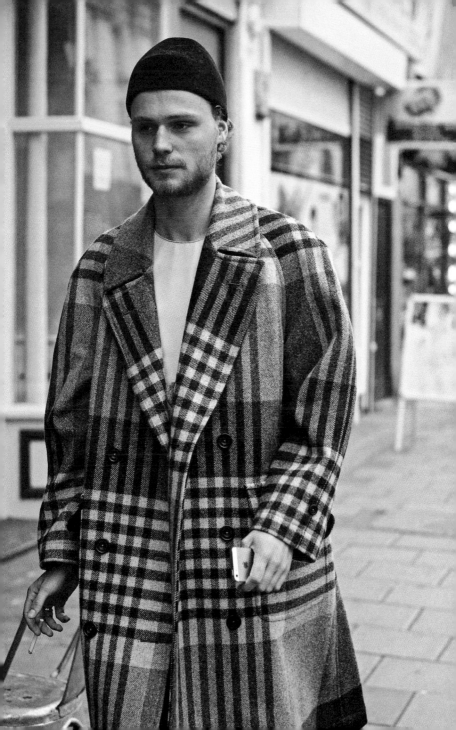

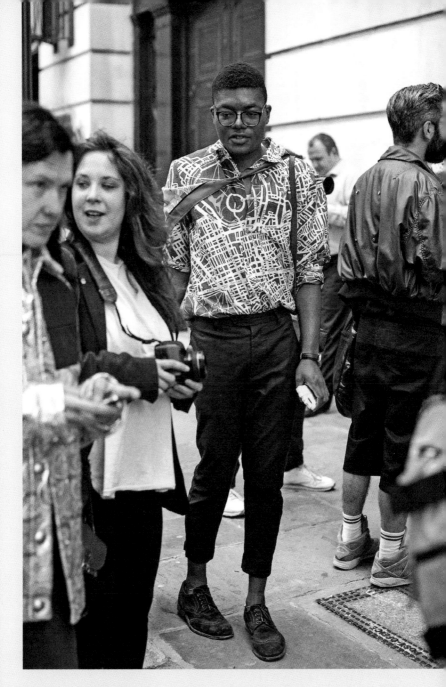

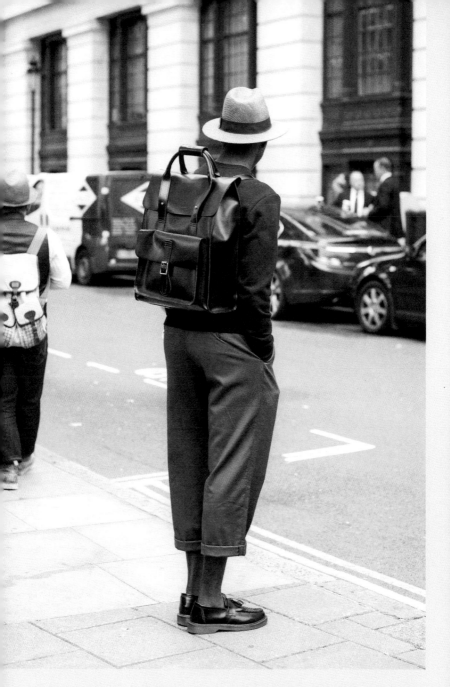

OVERSIZED ^ CANADIAN TUX ›

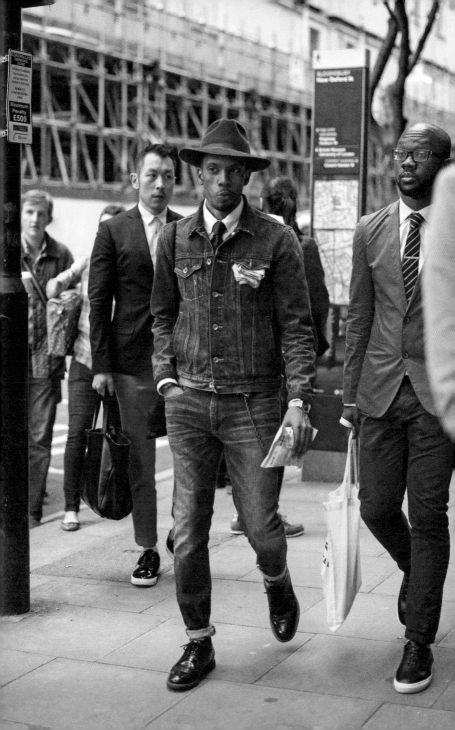

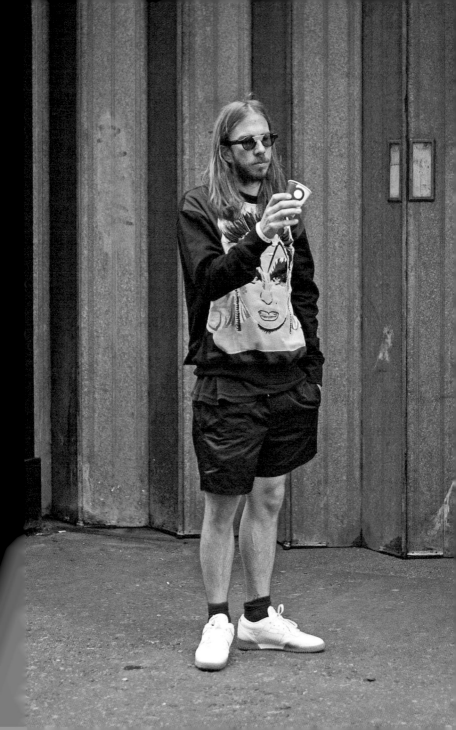

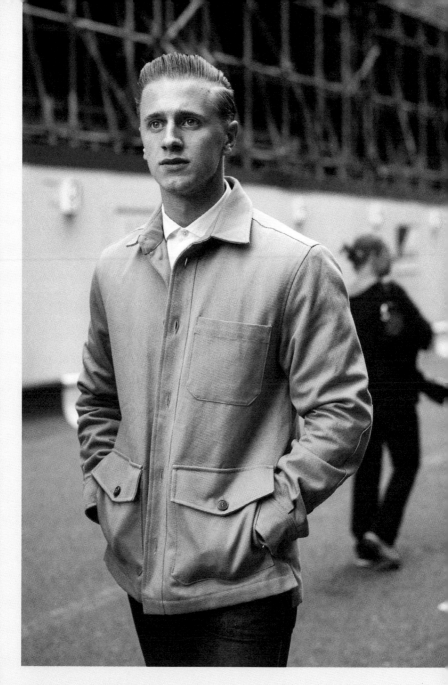

Classic meets modern with the now iconic Vivienne Westwood mountain hat.

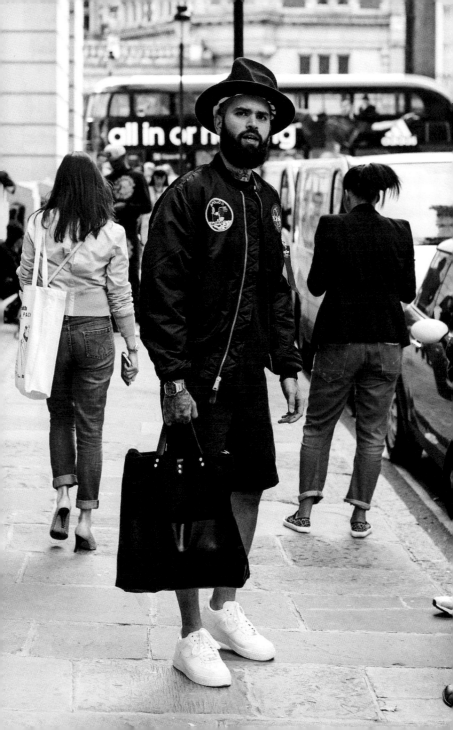

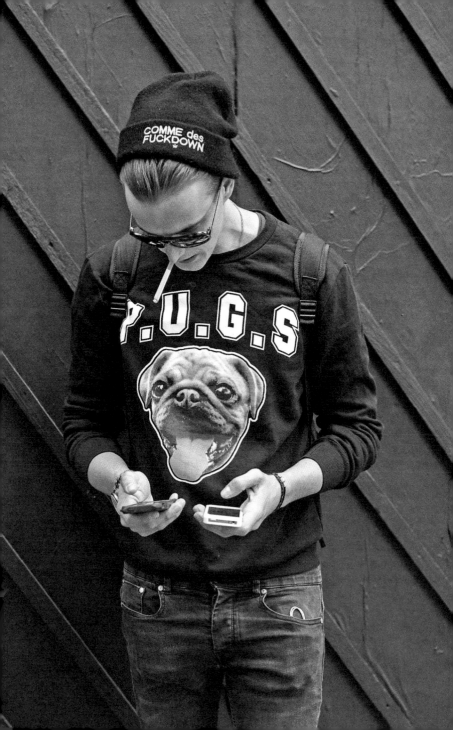

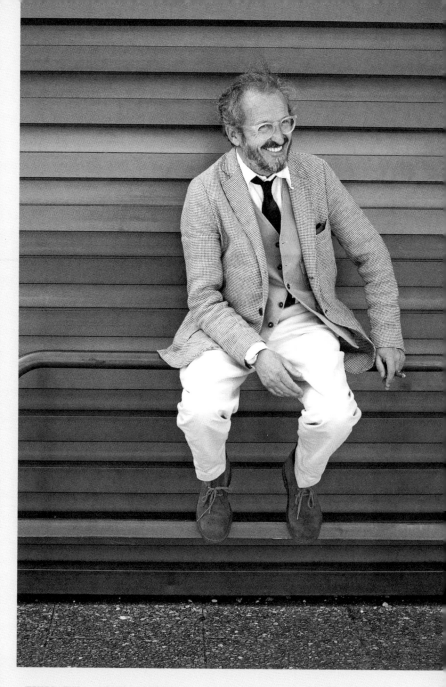

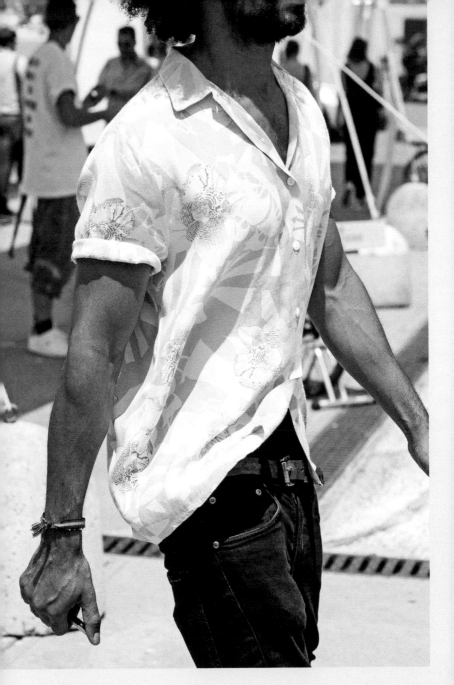

INSIDE OUT ‸ SHEER BLUE ›

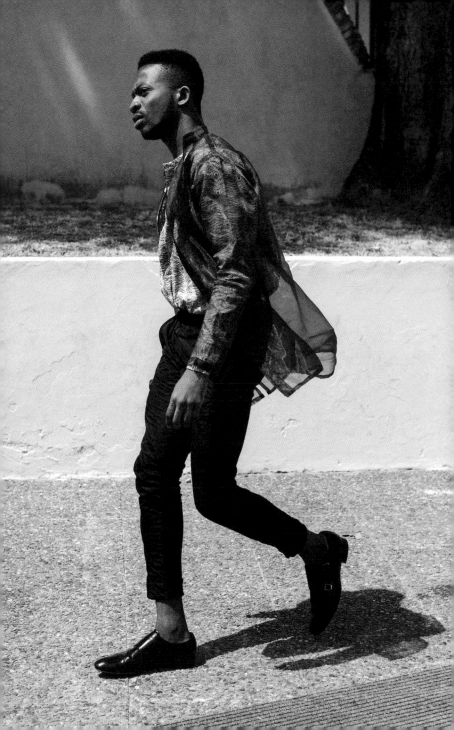

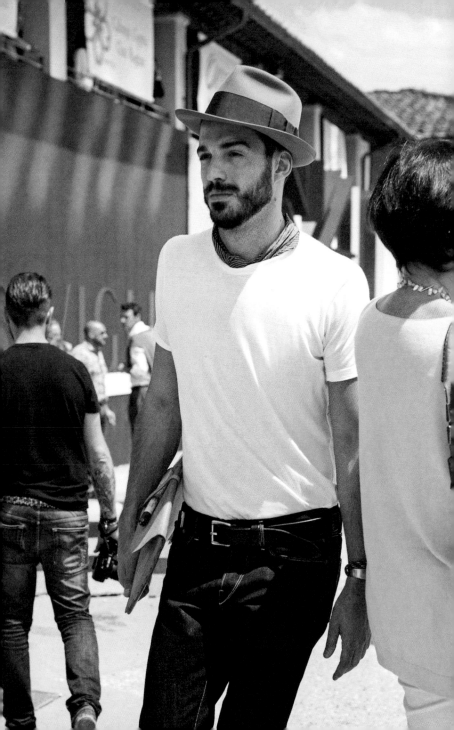

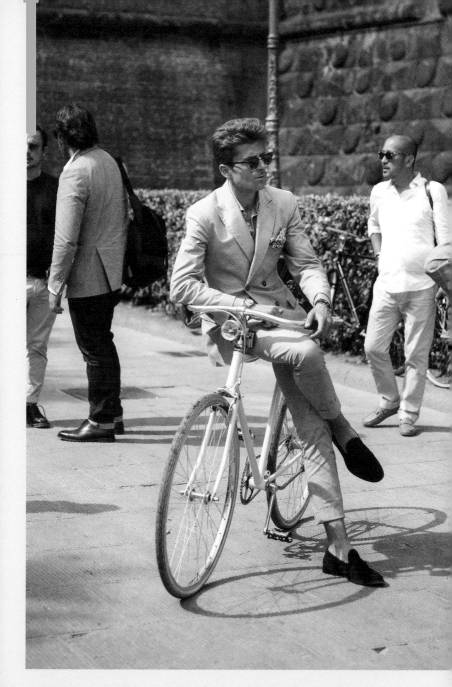

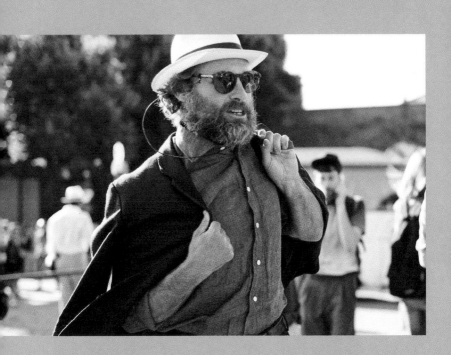

The art of wearing a suit in summer – the Italians have it covered.

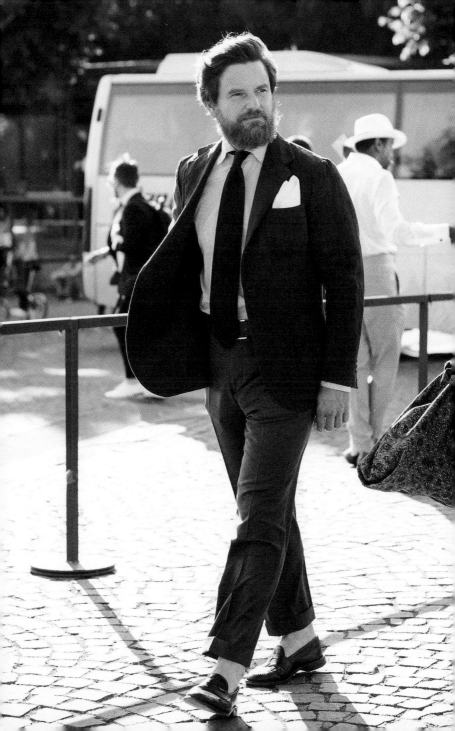

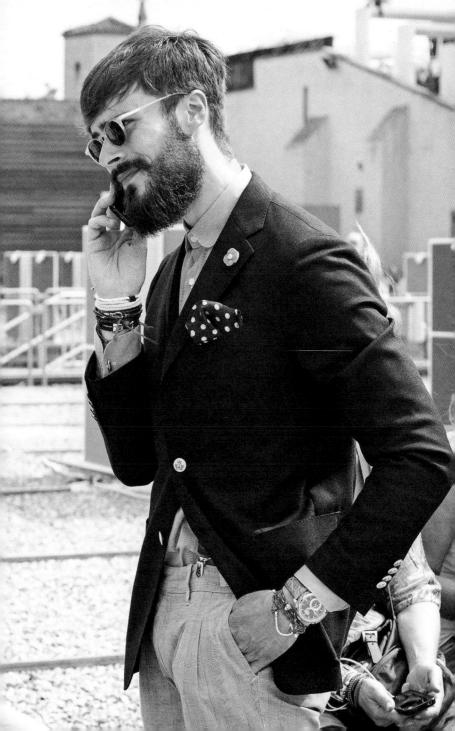

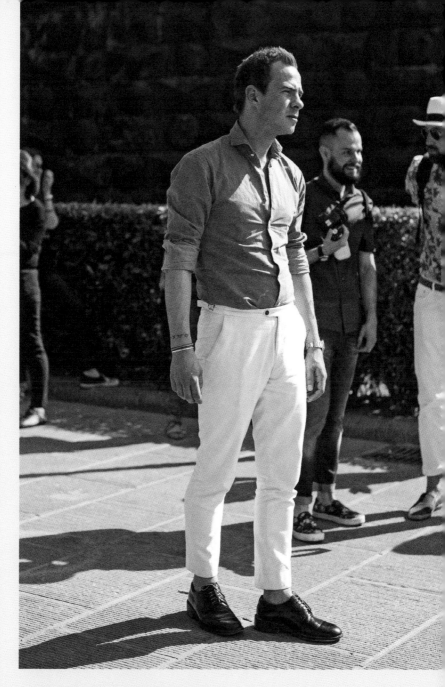

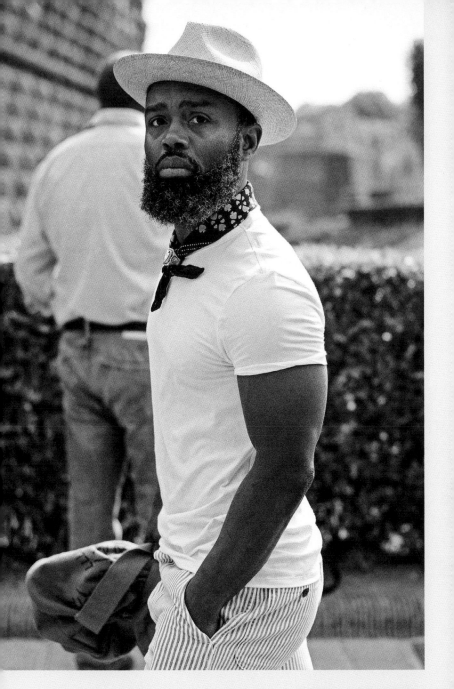

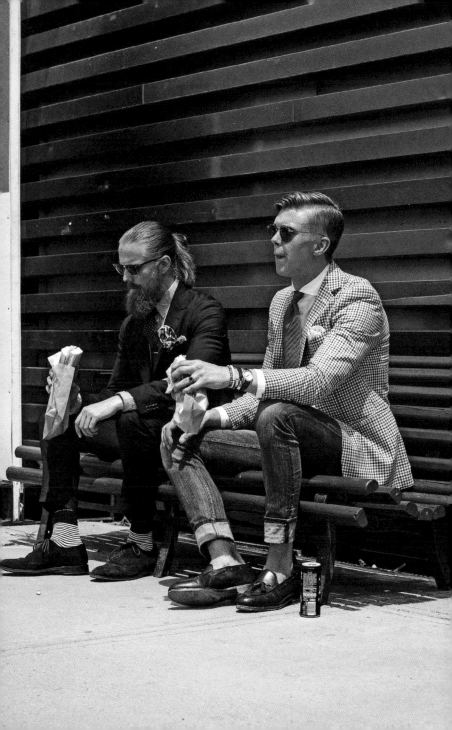

Indian *Summer*

Bringing my year of travel full circle, I returned to a much warmer New York City for the launch of my first book (which was exciting to say the least) and the Spring/Summer 2015 collections at NYFW.

The energy in New York during the warmer months is thrilling – the humidity in the air is thick, people are out on the streets, seemingly heading somewhere exciting and squeezing every last drop out of summer. Good times all around!

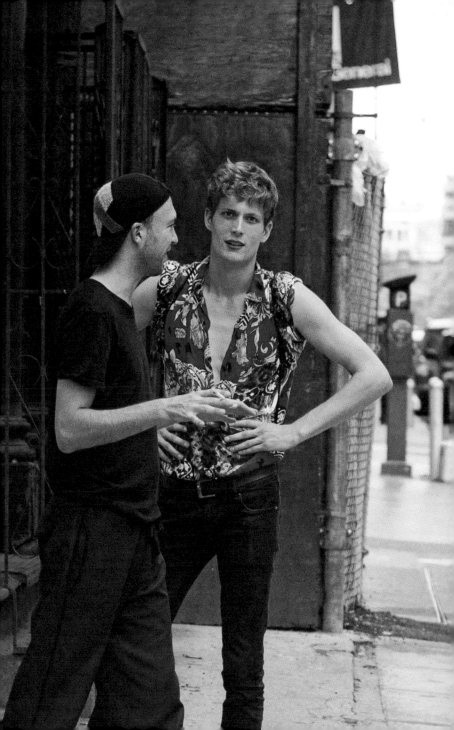

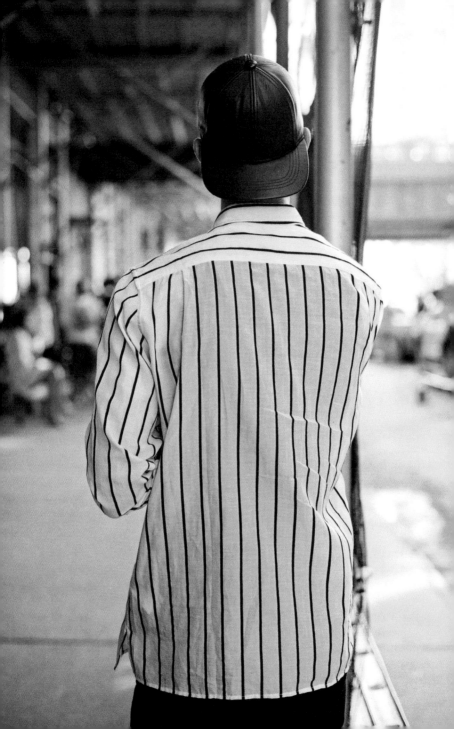

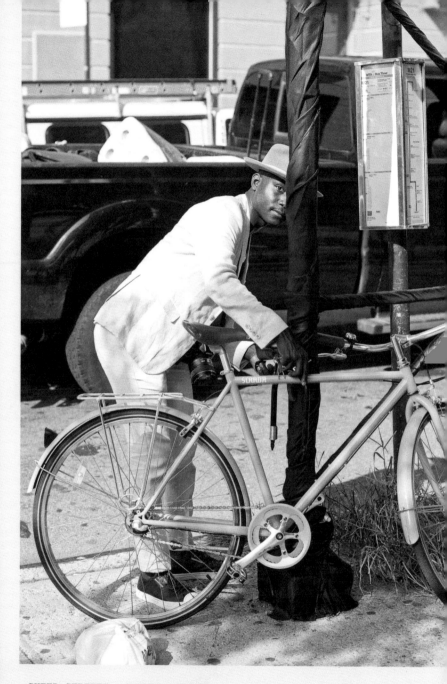

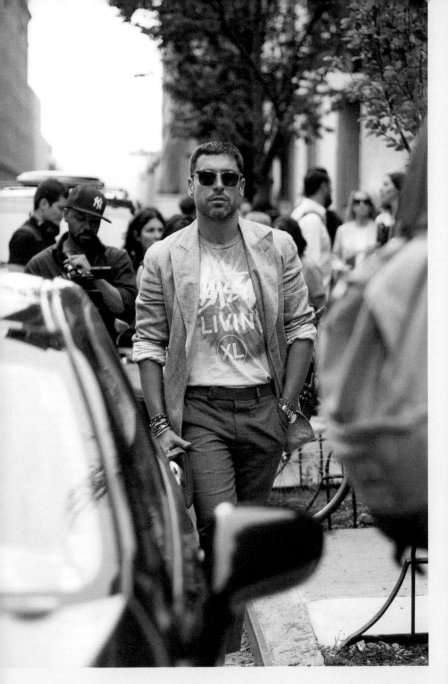

LIVIN' ^ HENDRIX ›

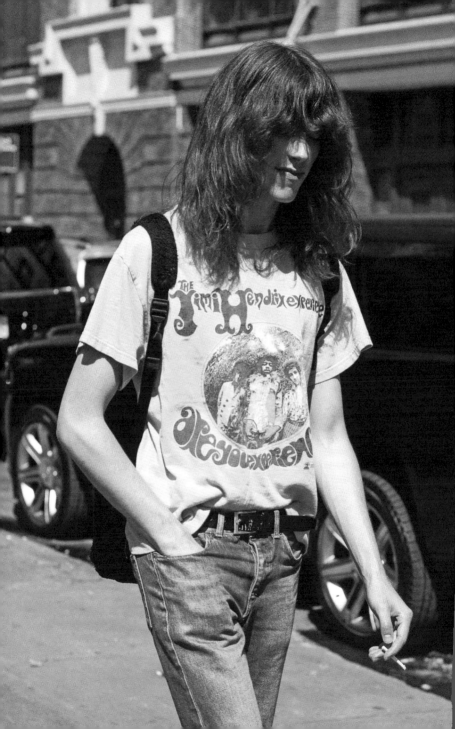

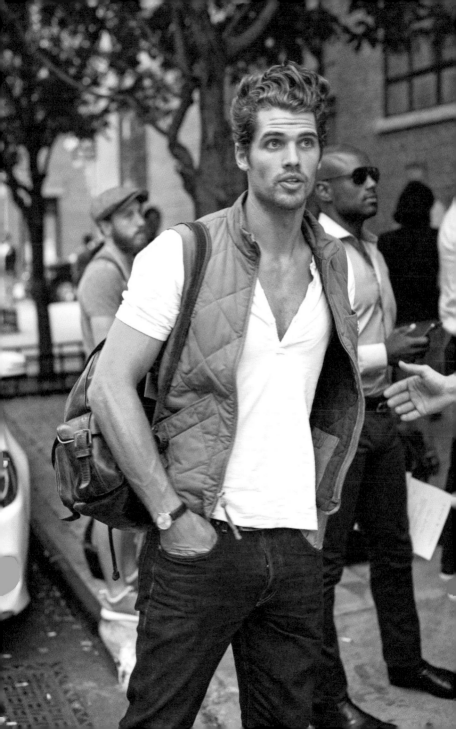

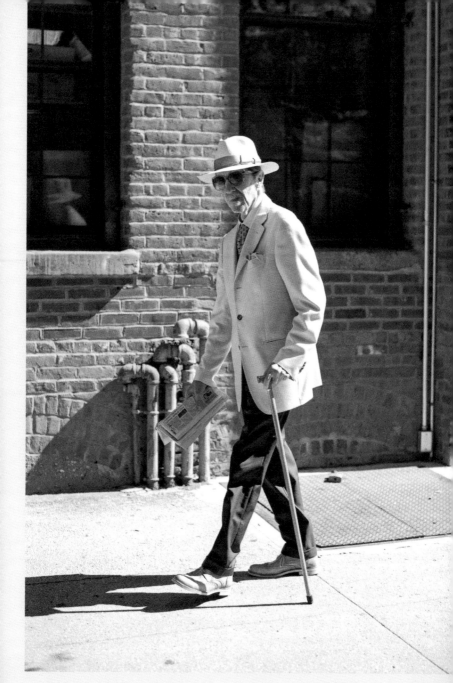

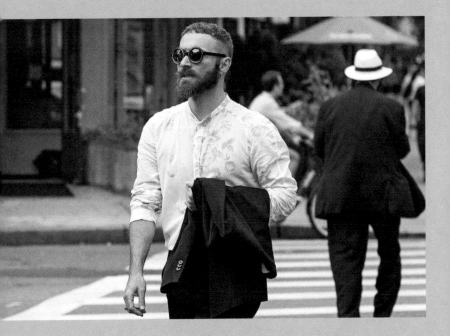

Blazer in hand as the days become shorter.

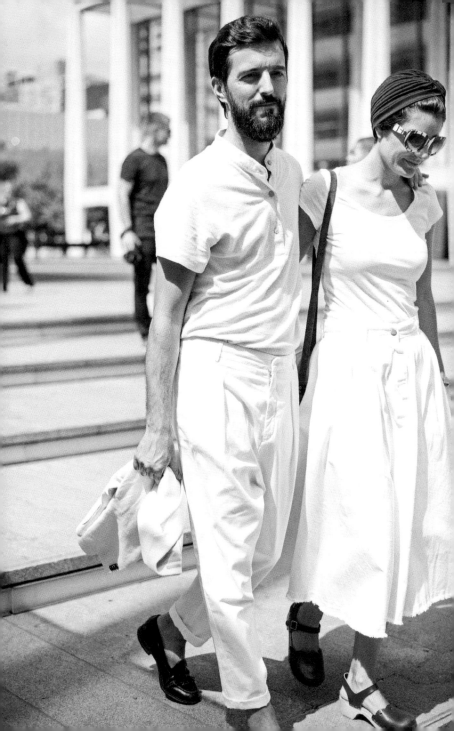

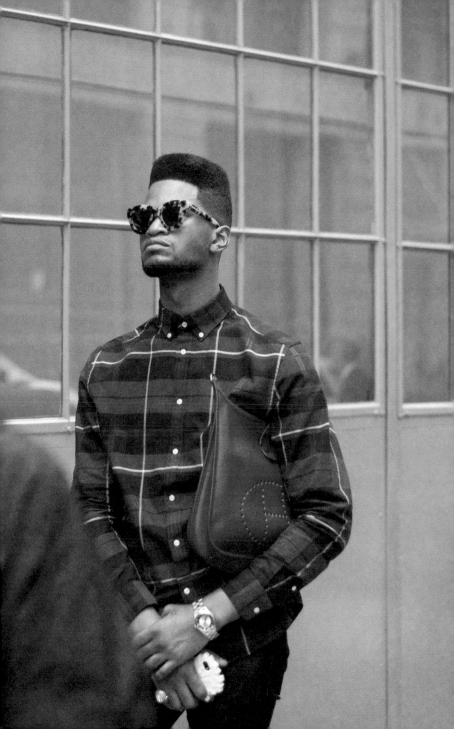

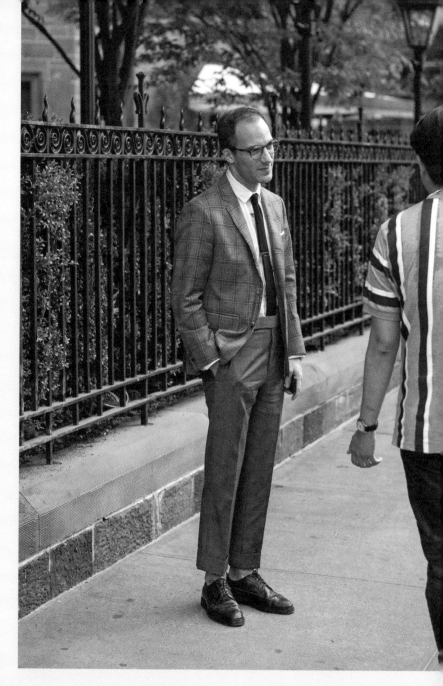

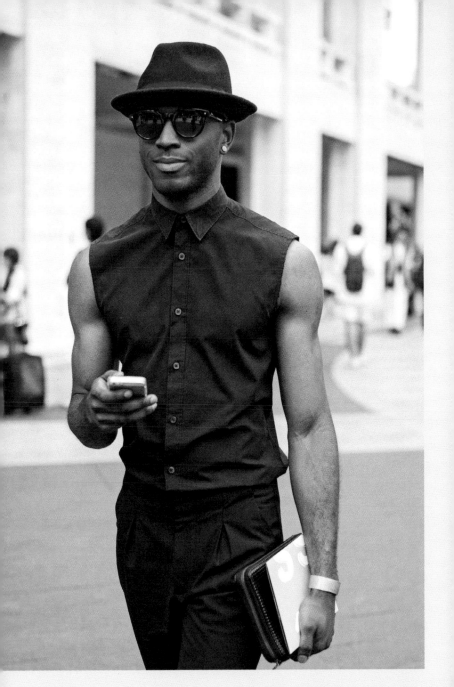

NO SLEEVES ^ NO SHIRT ›

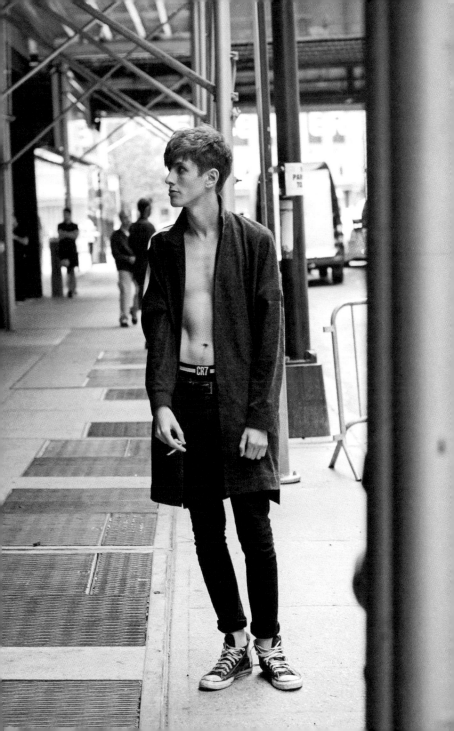

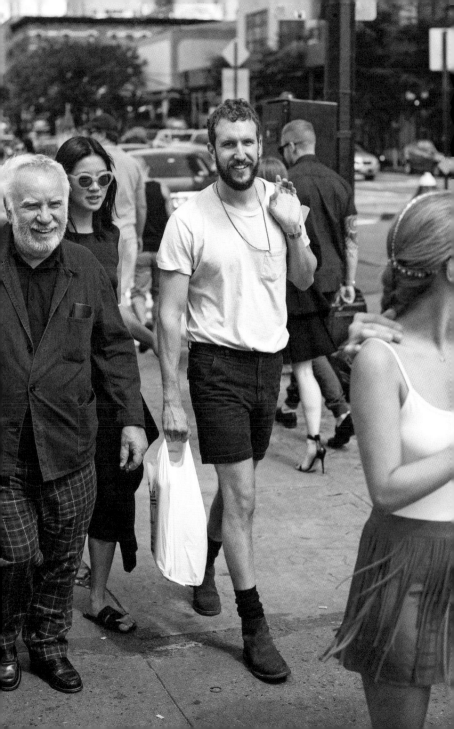

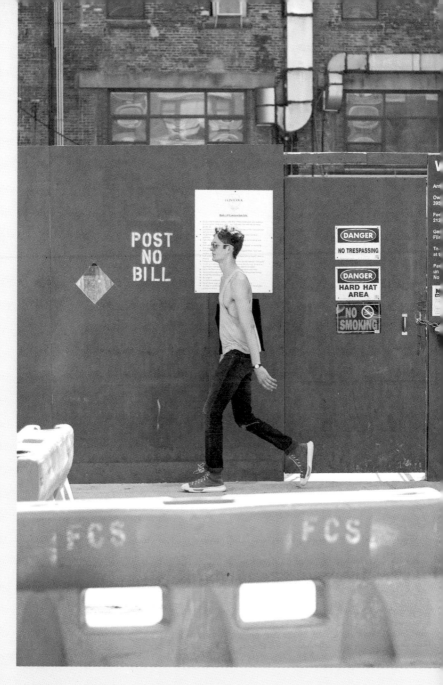

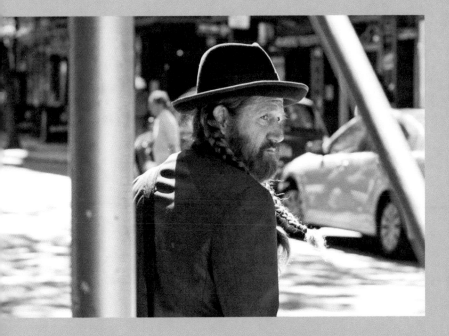

A window onto a
different time, at every
corner you turn.

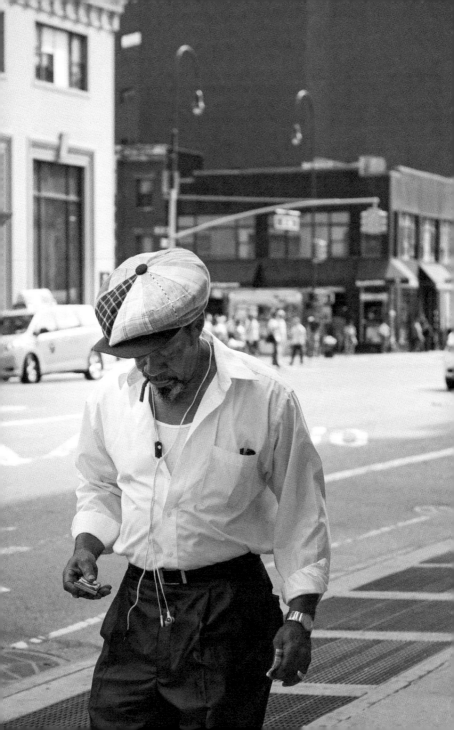

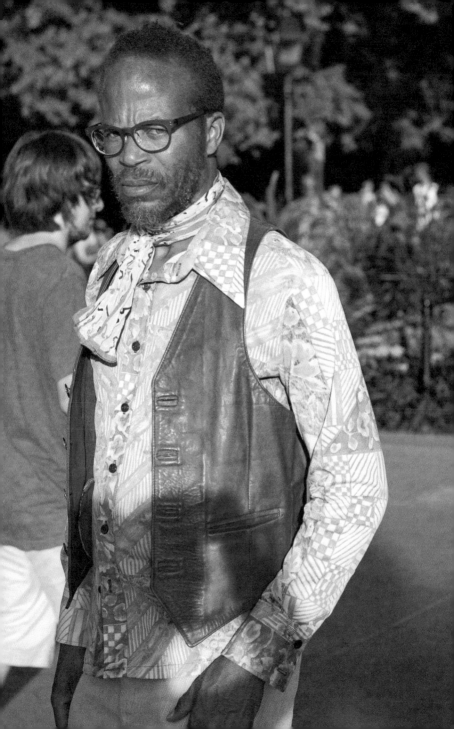

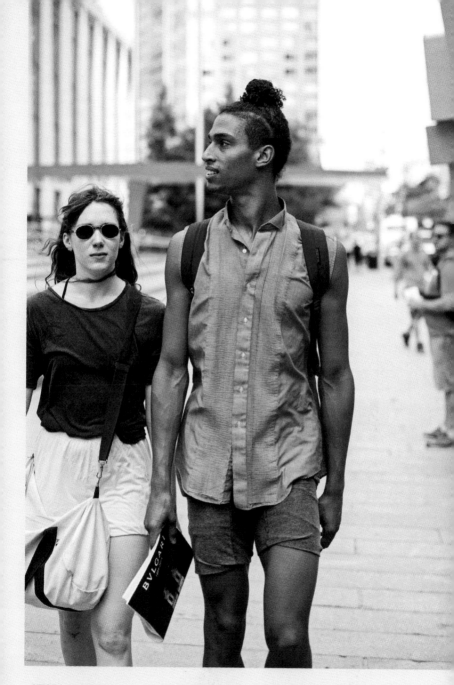

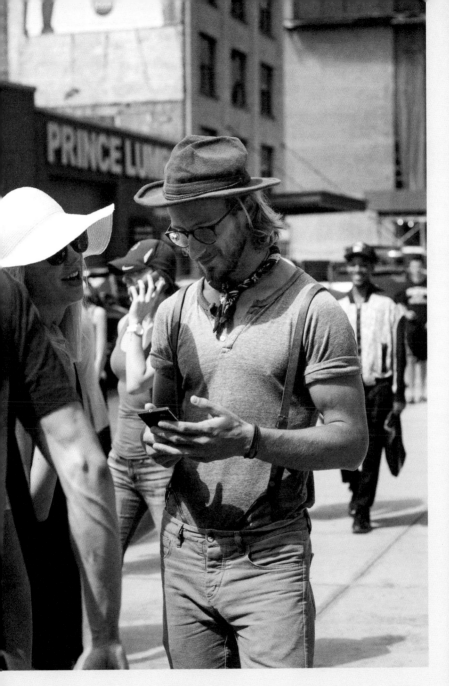

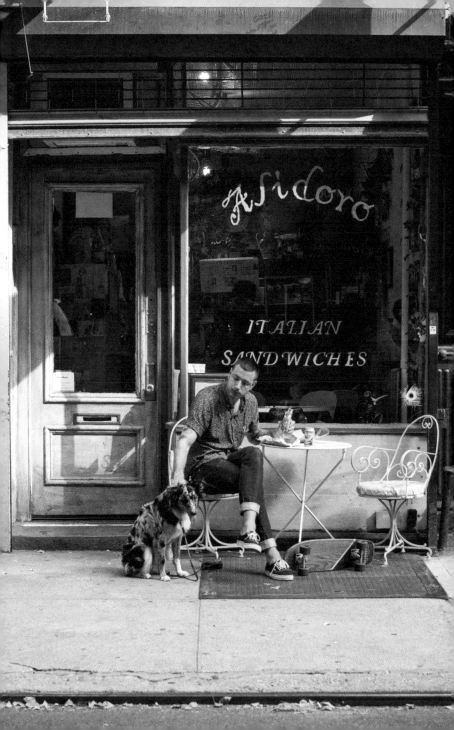

Two
Thousand
Fifteen

Blame It On *My Youth*

I first started shooting street style in 2010, a year or so after moving to Sydney. It seemed that menswear around the world was entering a new era at that time, and Australian men were taking note, more than ever. Women in Australia had never been afraid to experiment with fashion choices, but it hadn't really rubbed off on the men until then, so I wanted to document the development. Impressions from Melbourne (left pages) and Sydney (right pages).

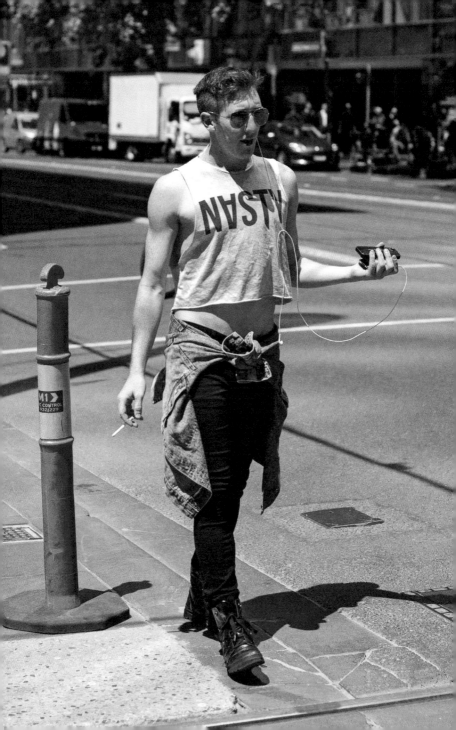

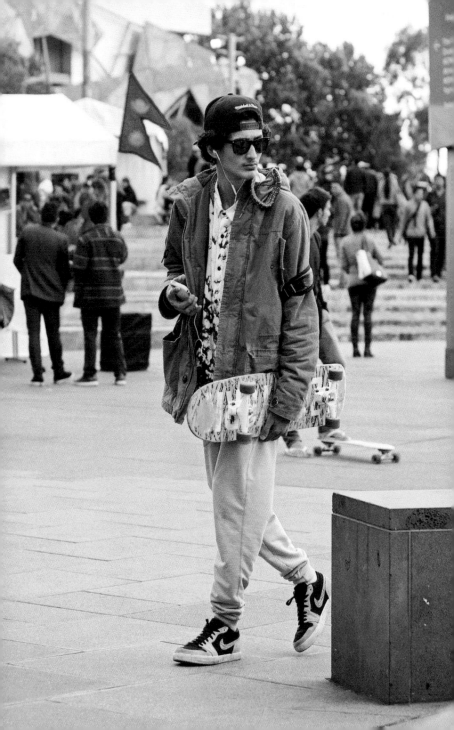

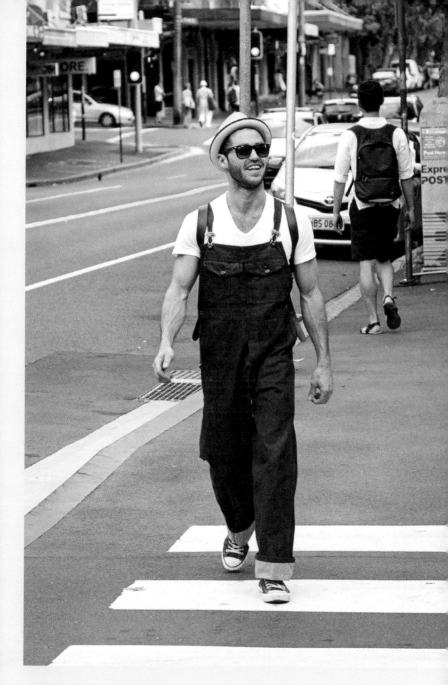

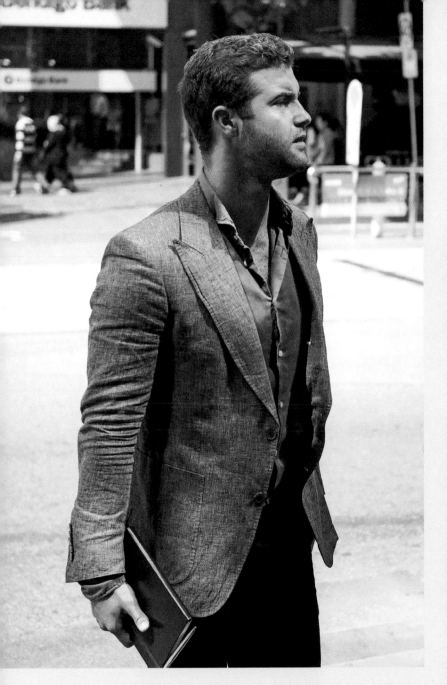

EMERALD CITY ‹ BATMAN ›

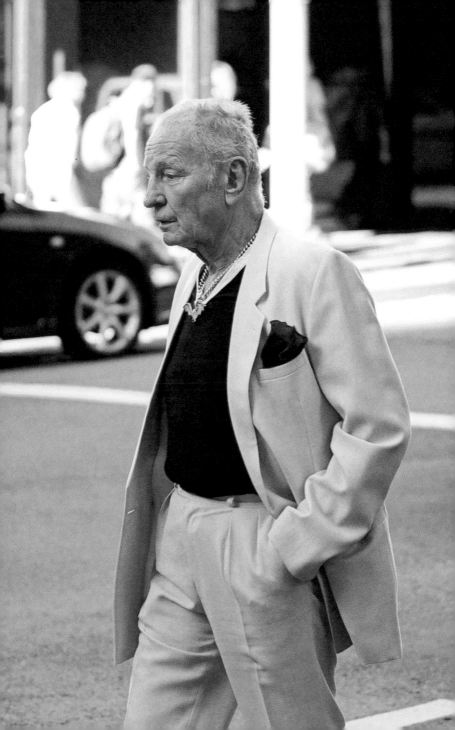

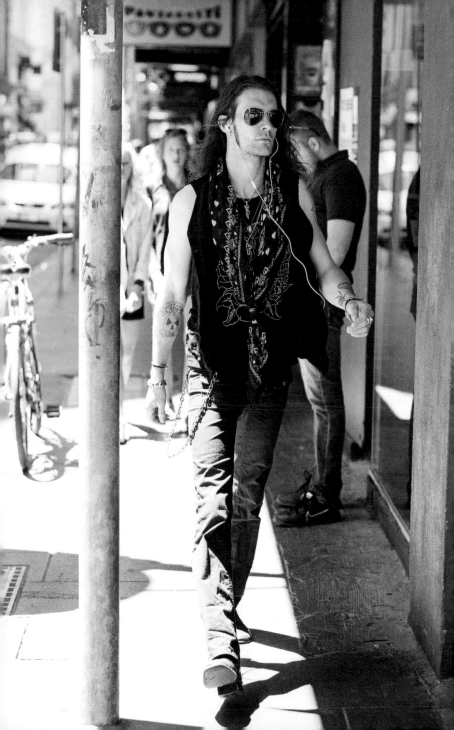

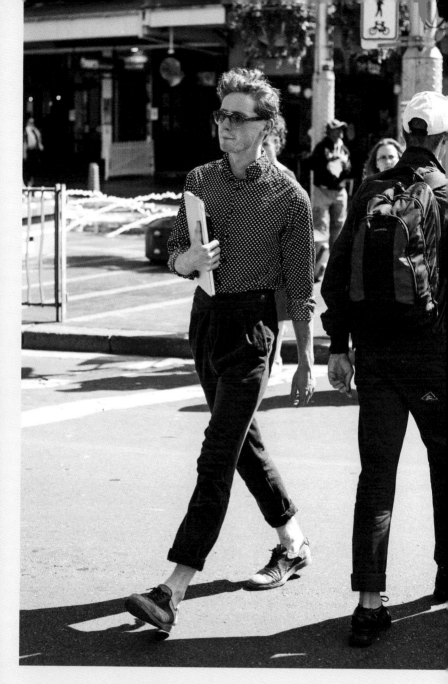

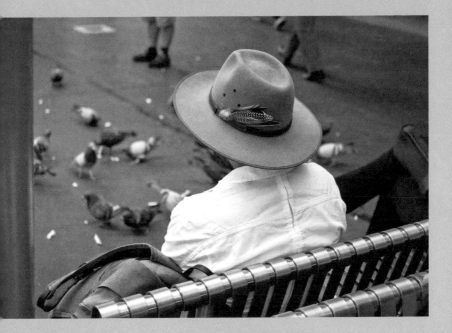

Wide-brim bush hat and
work boots – Australian
classics for a reason.

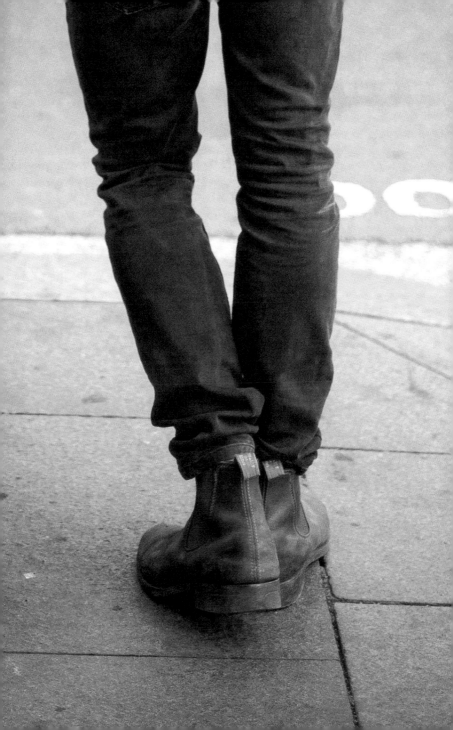

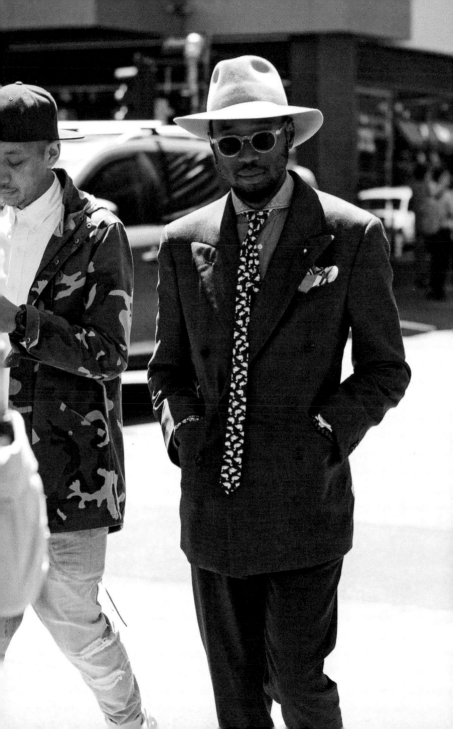

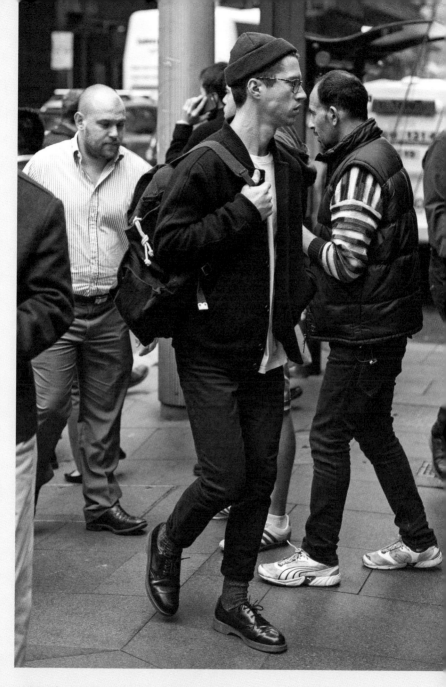

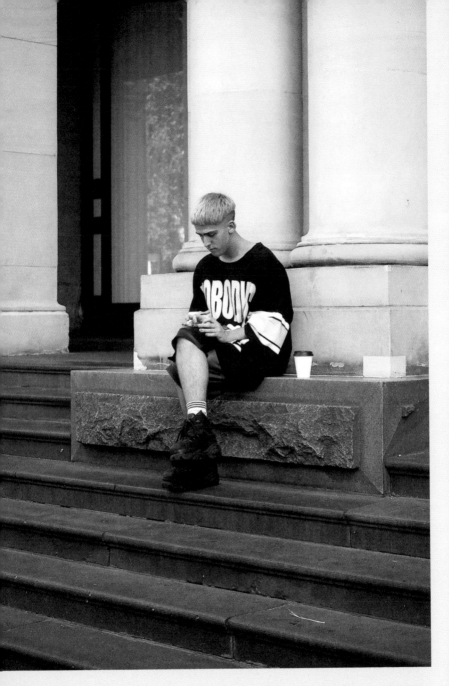

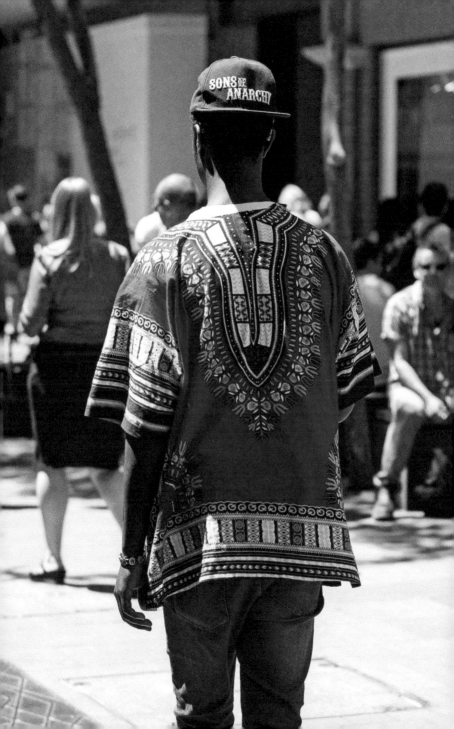

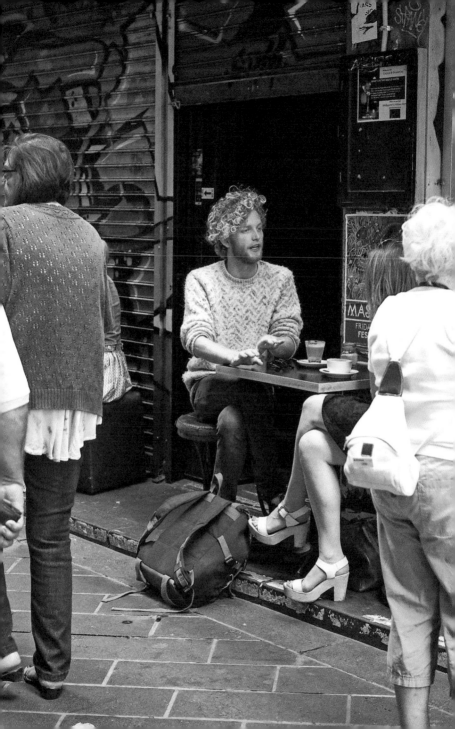

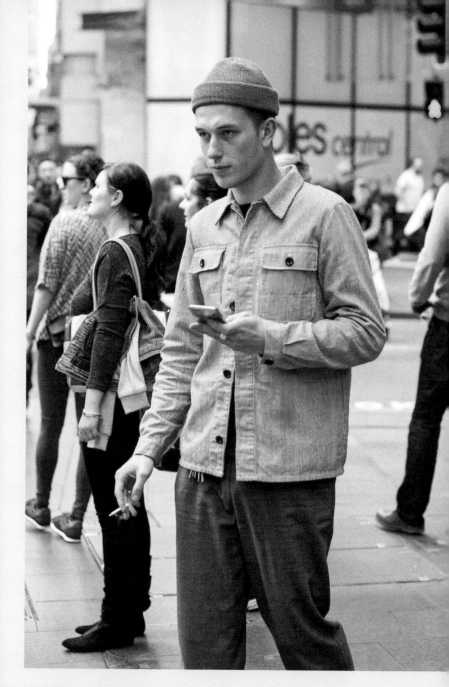

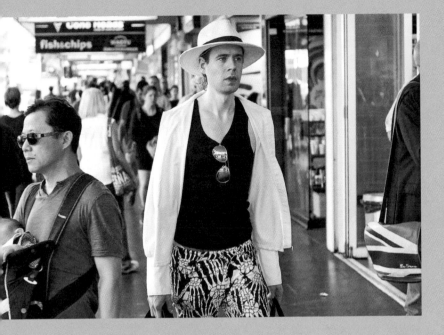

The eccentric characters
that inhabit the streets of
Melbourne and Sydney.

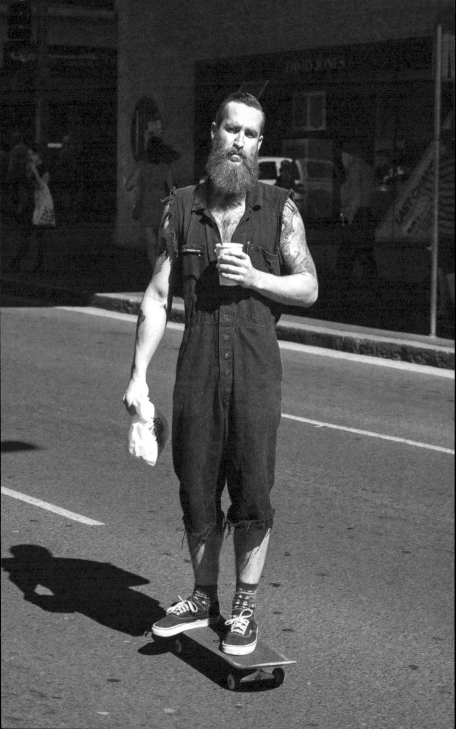

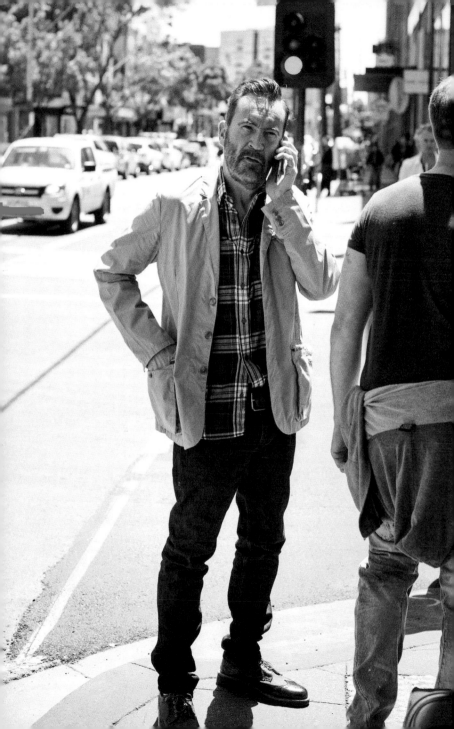

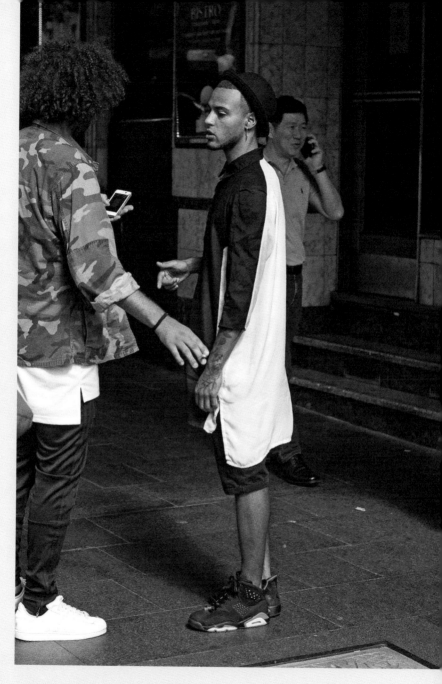

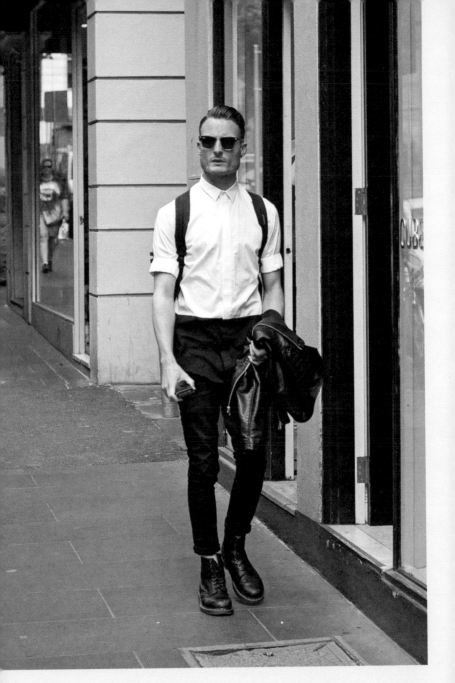

BUTTON-UP ^ ELASTIC ›

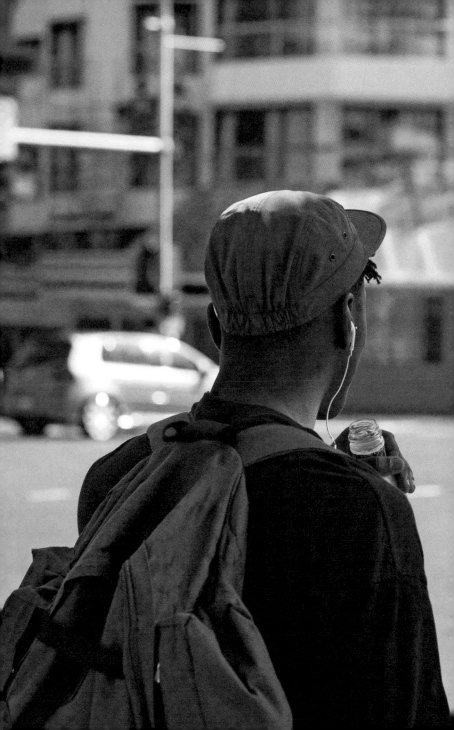

Lush *Life*

Tokyo and London are two of my favourite places to visit. Their histories and cultures are an endless source of inspiration, and the cities' inhabitants exhibit looks worth capturing at every corner.

There is a sense of fearlessness in London fashion choices (right pages), and the attention to detail in Tokyo (left pages) is always on point, no matter what the style or trend. My trips are usually too short for all there is to capture — I plan on returning soon!

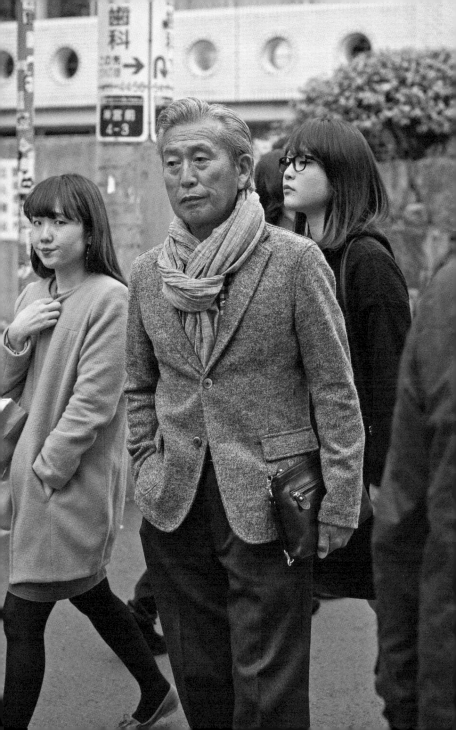

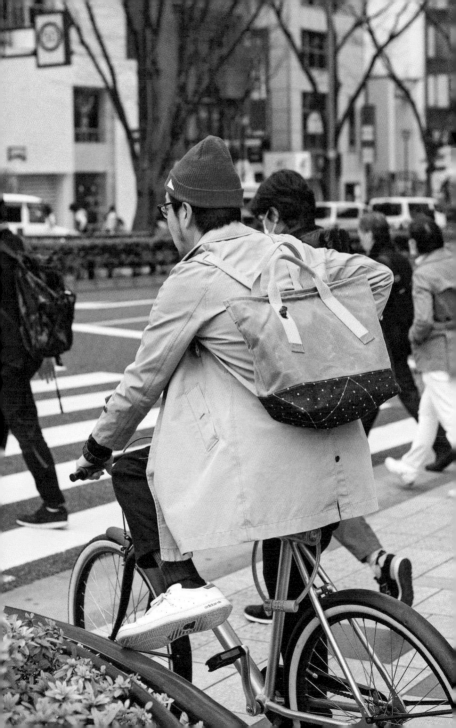

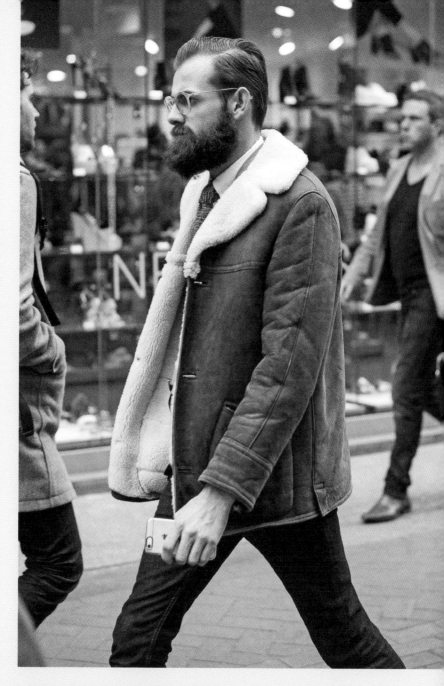

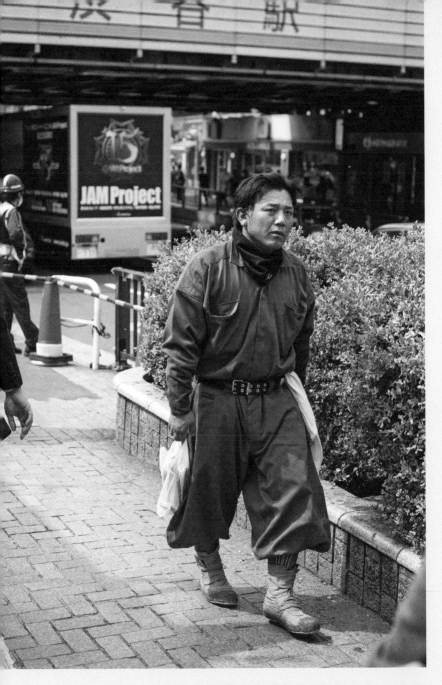

TOKYO TRADITIONAL · LONDON LAYERS ›

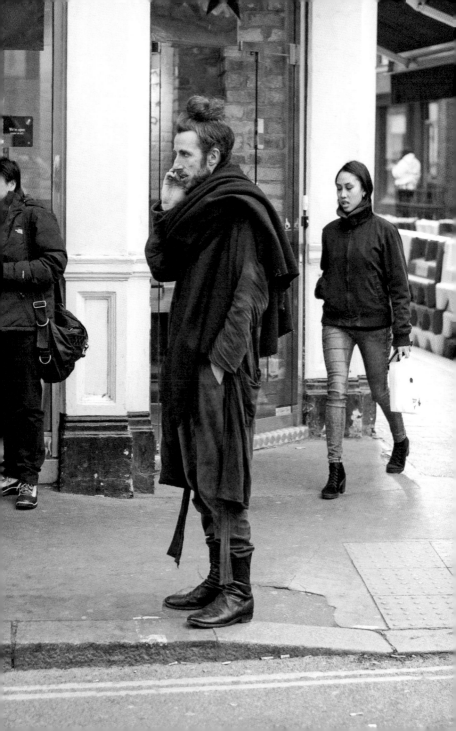

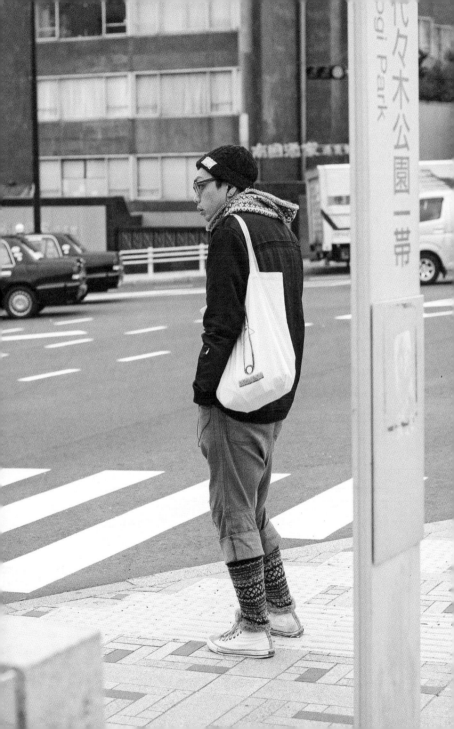

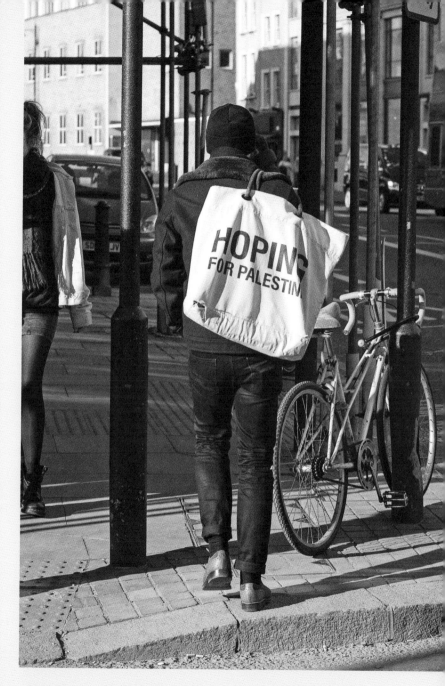

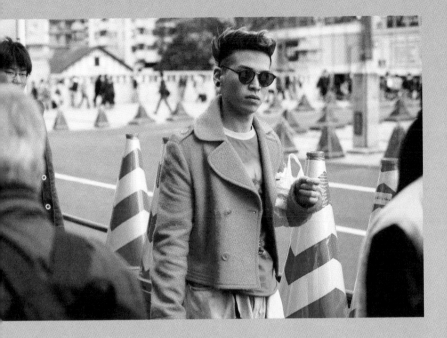

Animated influences
on the streets.

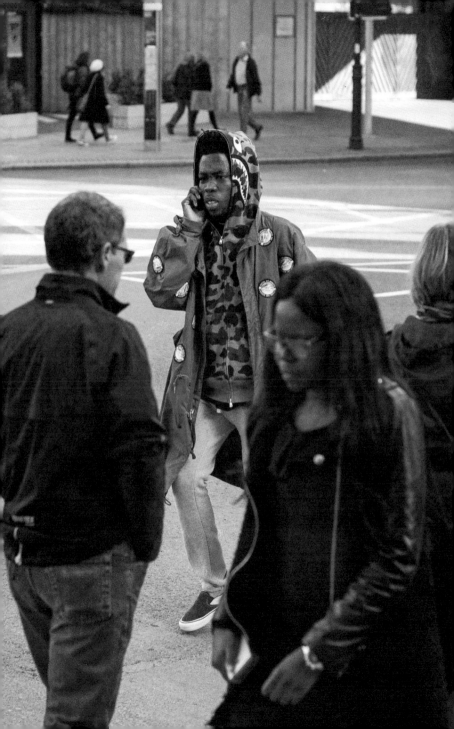

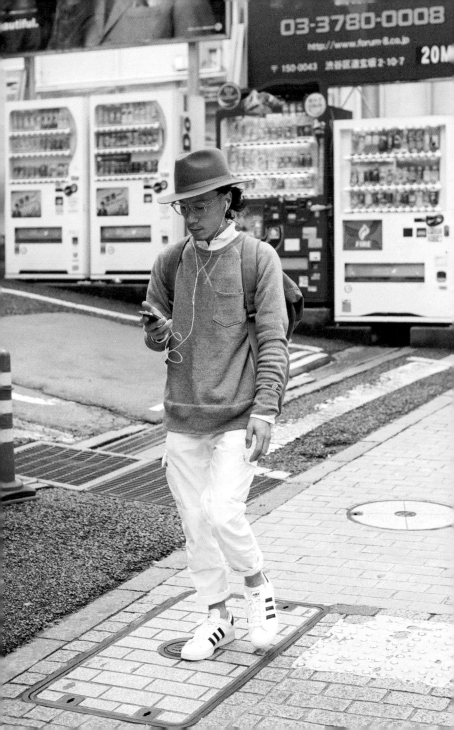

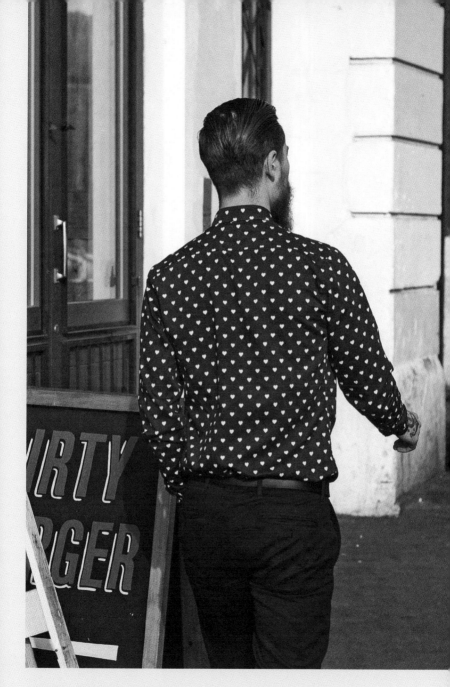

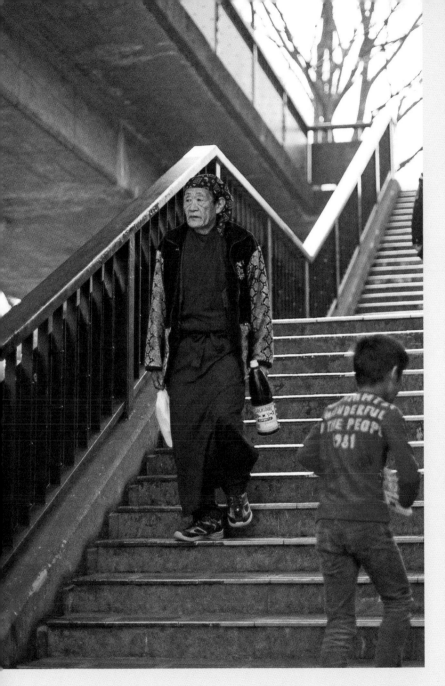

BANDANA ˄ · LEATHER HORIZON ˃

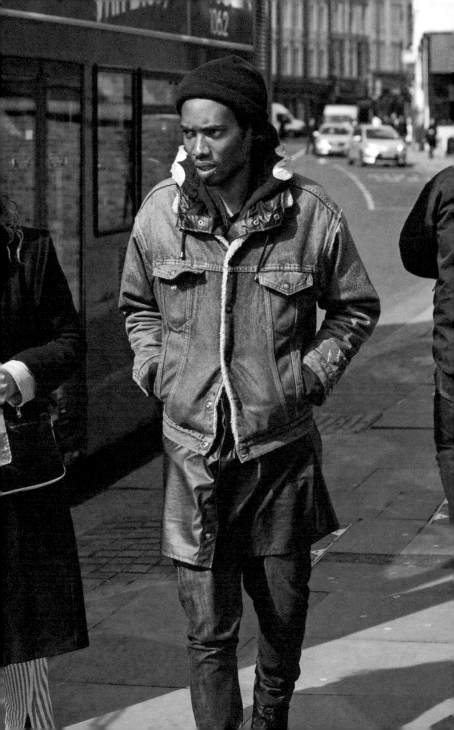

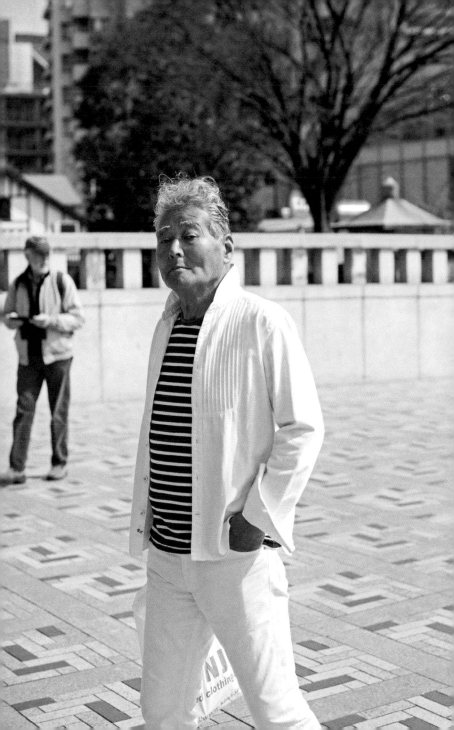

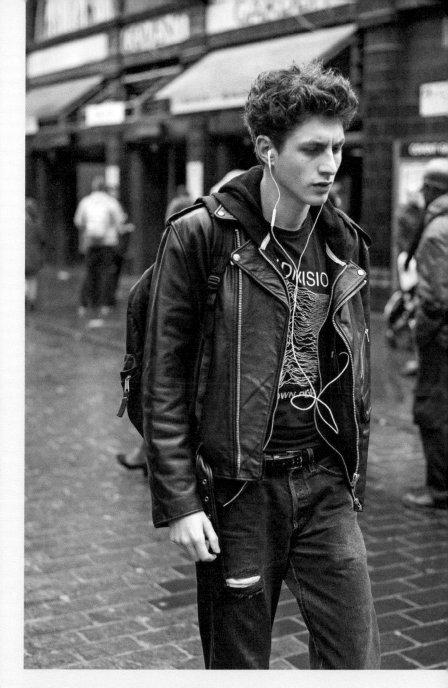

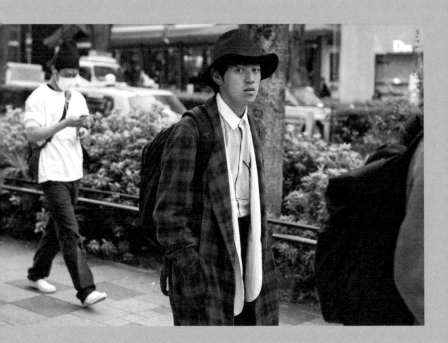

Rich tones and pattern
play add layers to the story.

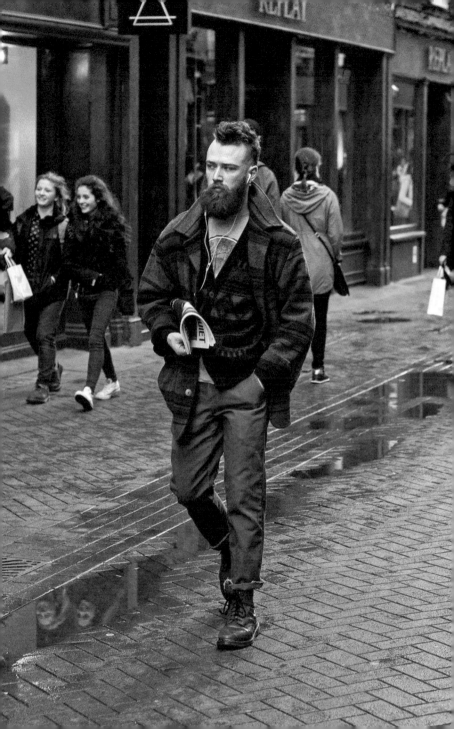

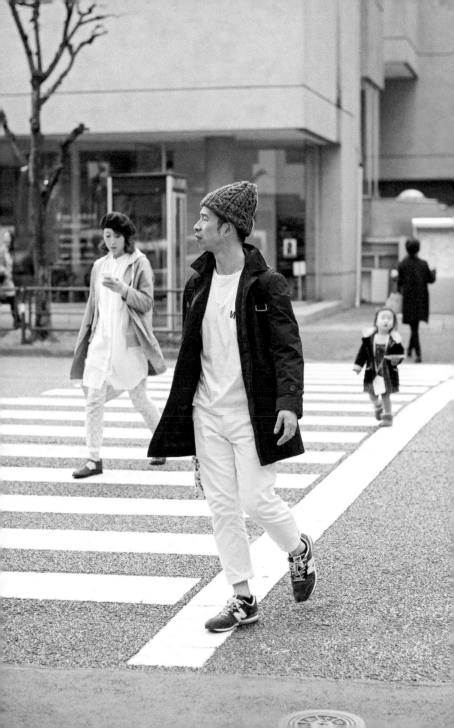

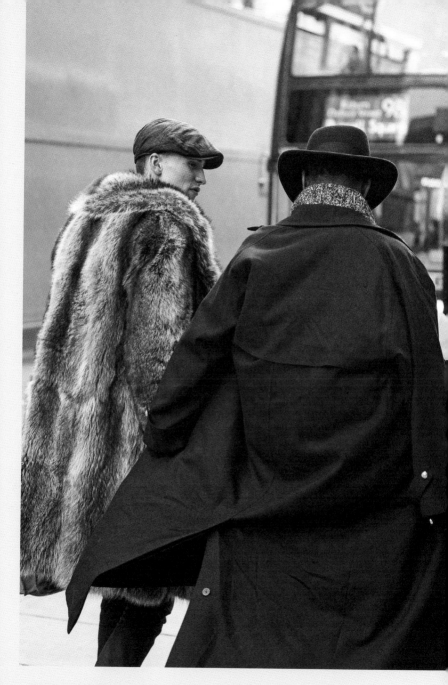

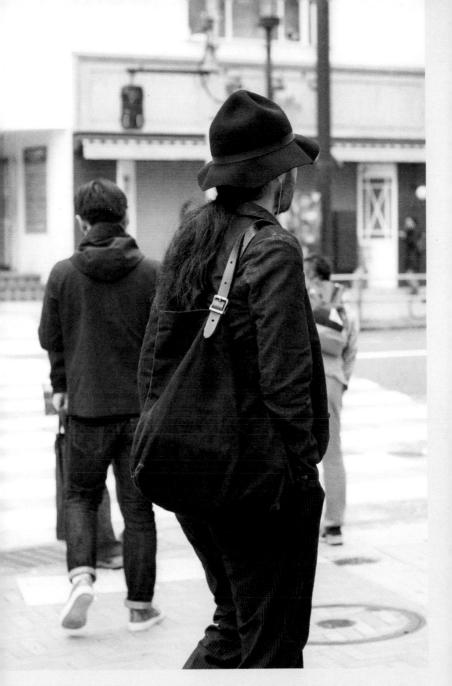

ENU

HLY MADE
fels Wraps

LAR £3.50
GE £4.50
uliflower/
bergine £0.50p

UT BREAD
fele with salad £3.50
els with salad £4.50

drinks £0.80p

are made from chickpeas
ans, sesame seeds, served
mous, tahini, our own pickles
d chilli sauce

TARTAN & VEGA

That Old *Feeling*

My first experience in France was in 11th grade as part of a class trip. We drove around the country in an oversized bus, stopping in various towns, and eventually ended up in the city of lights. I don't remember much about the trip, being a typical teenager at the time, but I do remember Paris had a great impact on me – I knew I would return one day to properly take in its true beauty.

Twelve years later, I had the opportunity to explore the streets and avenues and photograph the people of Paris, just like street photographers of the past have done so beautifully.

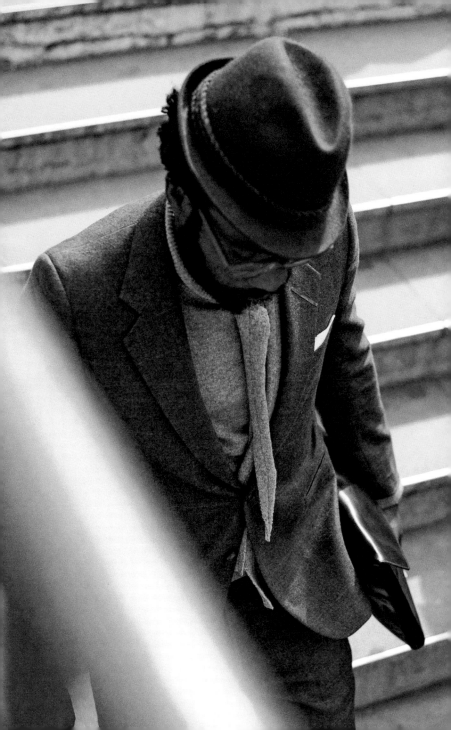

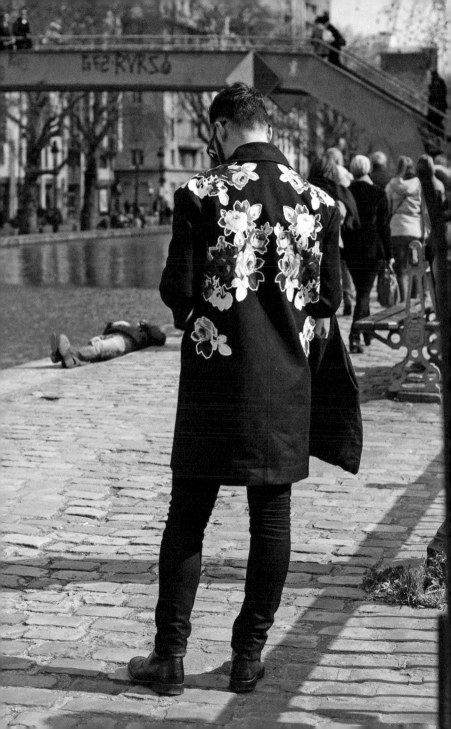

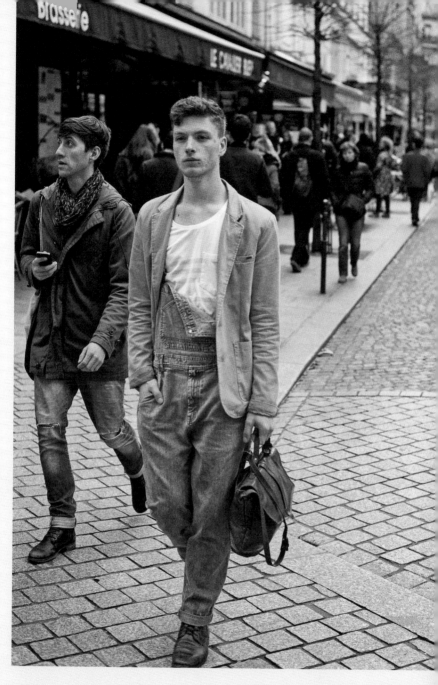

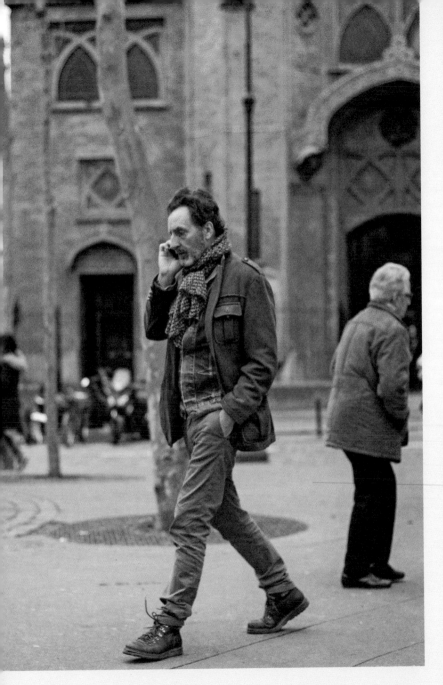

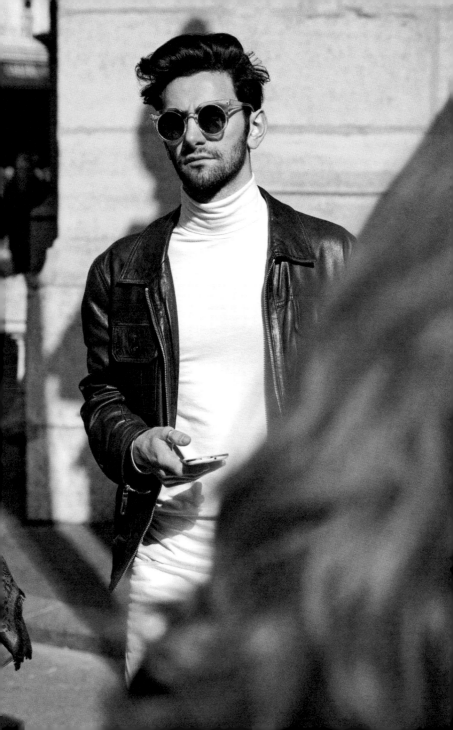

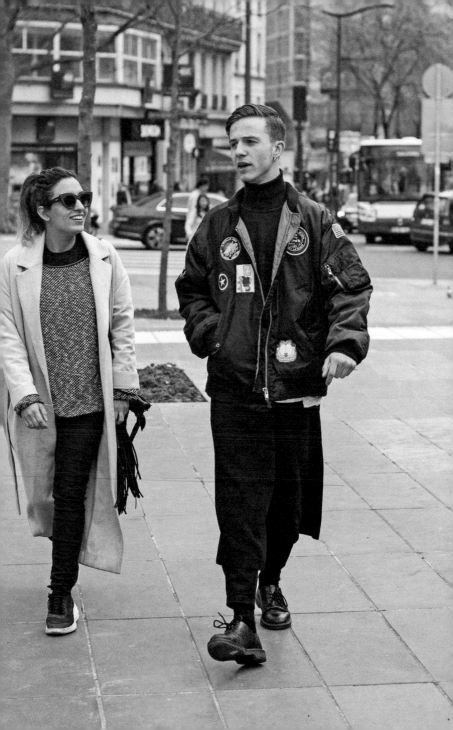

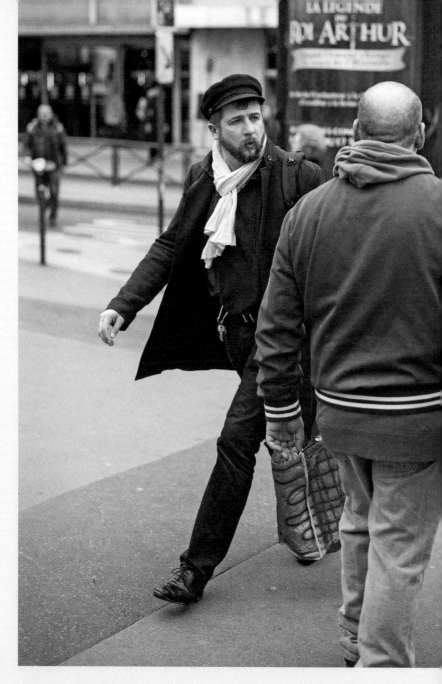

‹ DUDE ˄ GONE FISHIN'

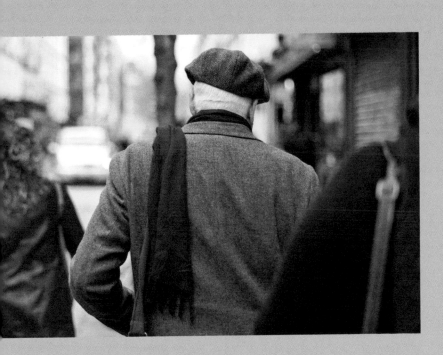

A scarf over the shoulder
– it's all in the simplicity.

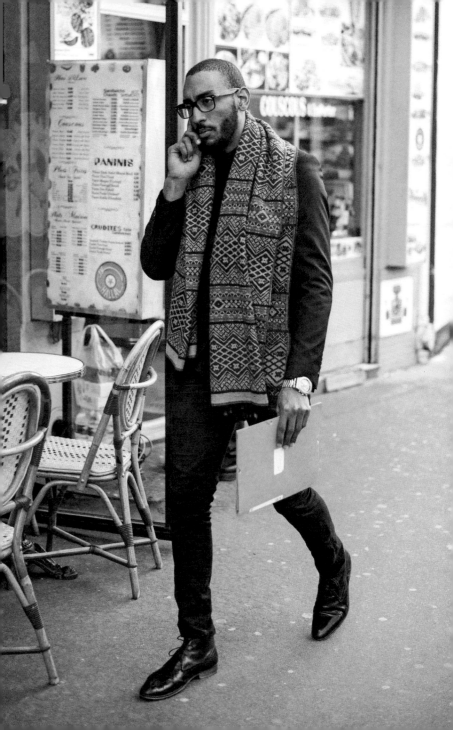

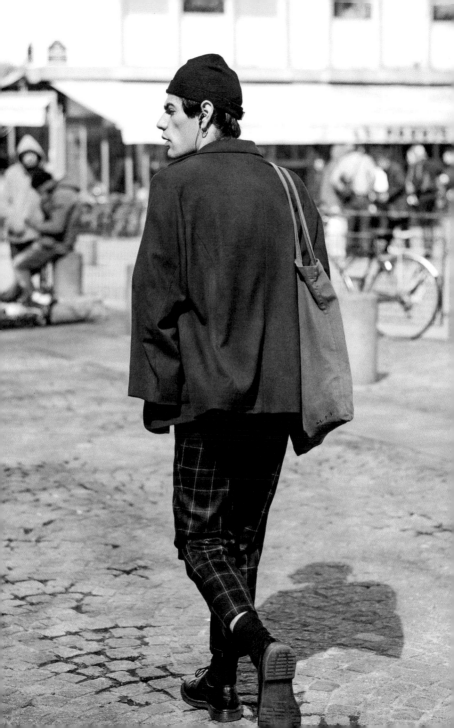

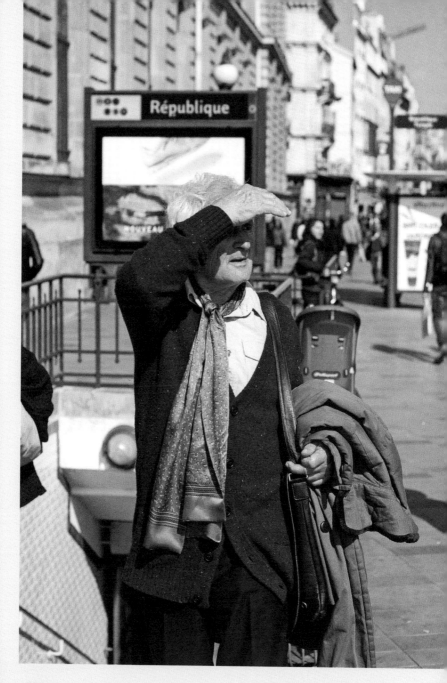

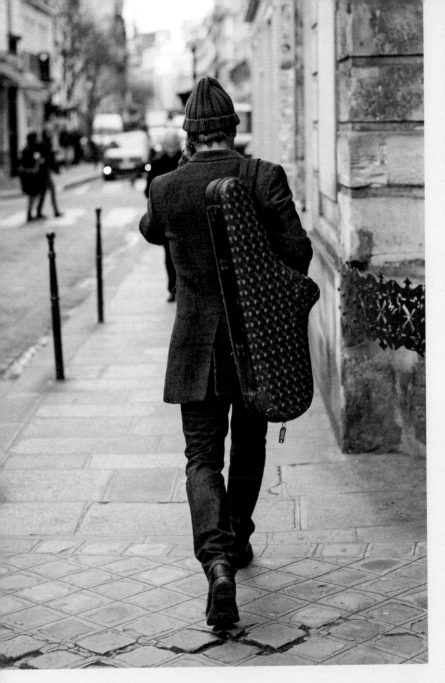

CASUAL SAX ^ BUBS ›

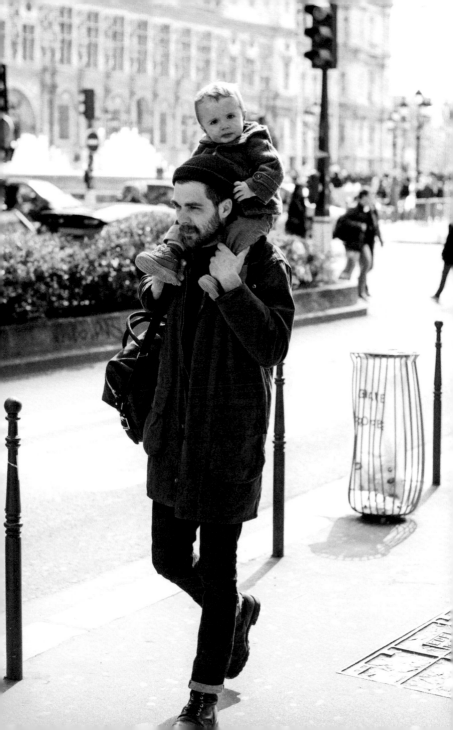

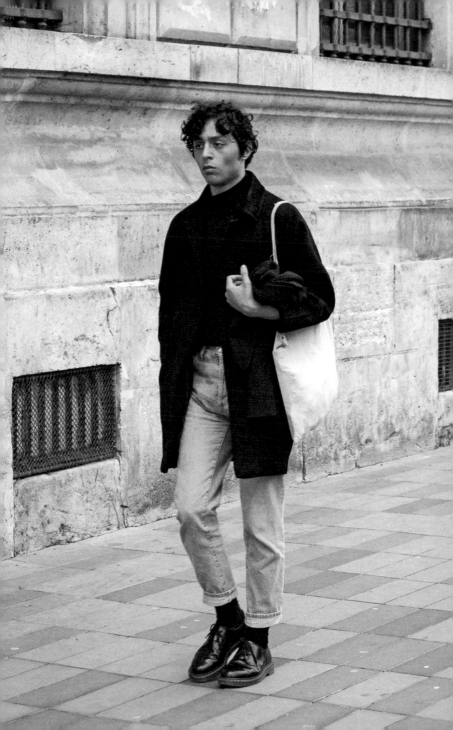

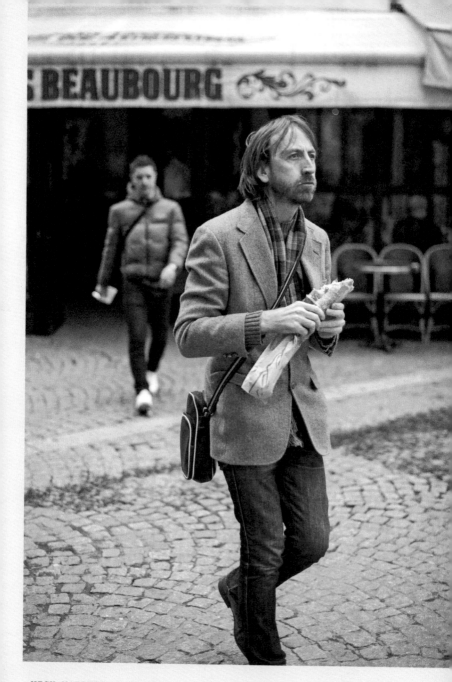

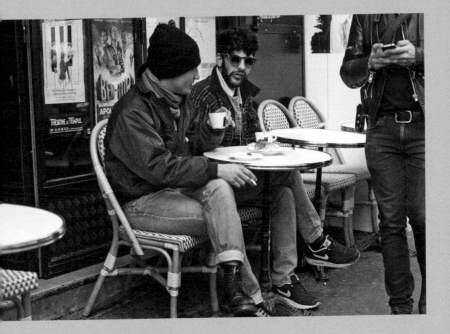

The café culture and busy streets make for the best people watching.

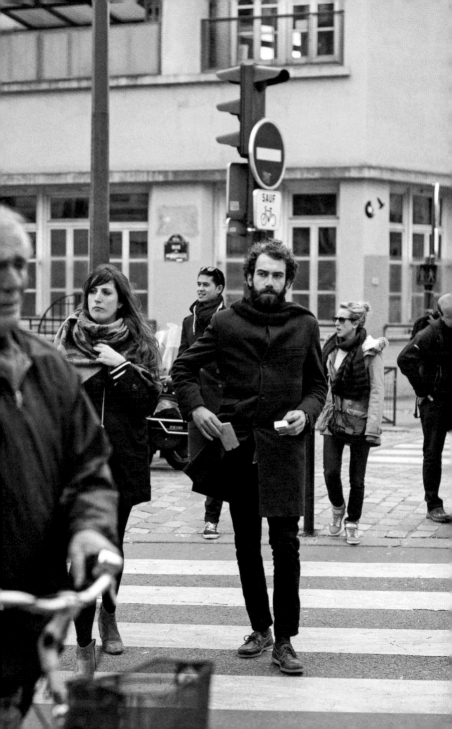

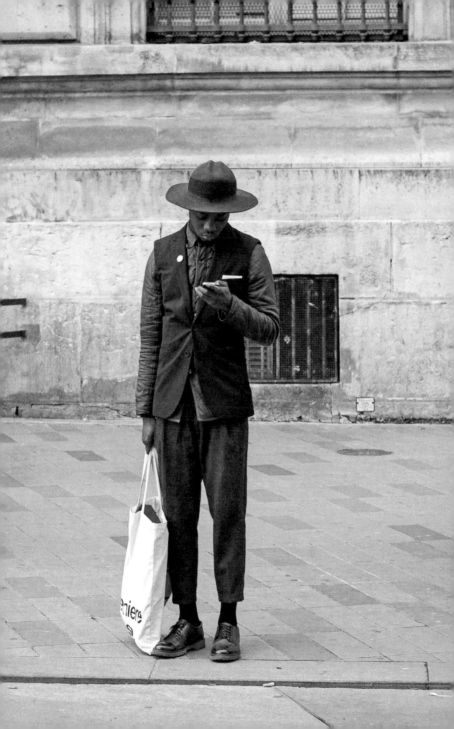

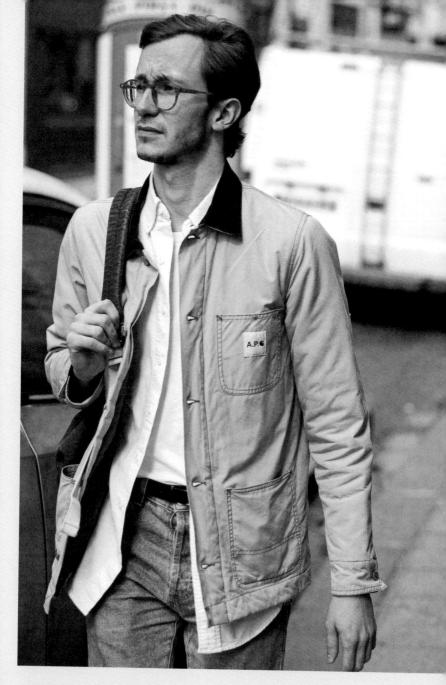

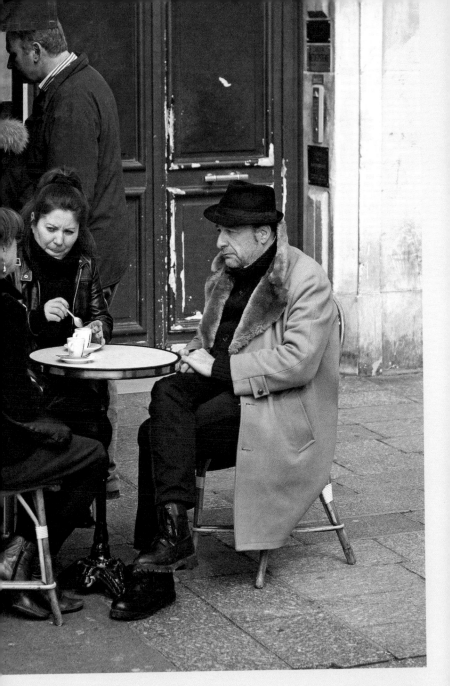

FUR LAPEL ˄ · METAL LINES ›

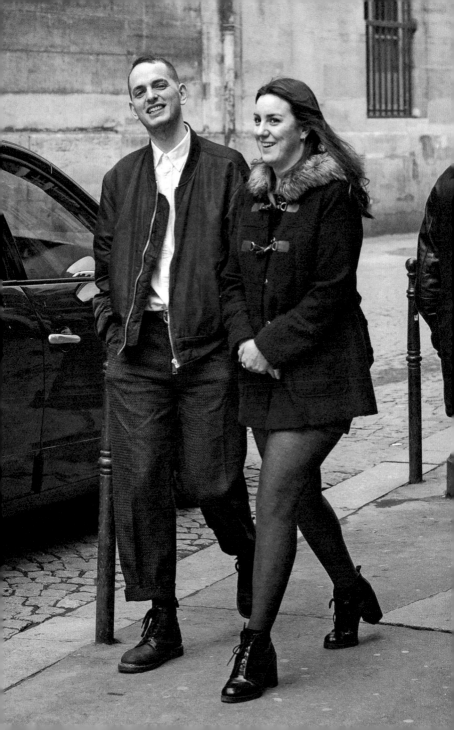

How Long Has This Been *Going On?*

After my visit earlier in the year, I knew another trip to Japan was a given. As futuristic – for the lack of a better term – a city like Tokyo can seem, there is definitely a nod to its heritage in every element you encounter. I wanted to explore this relationship in the style choices being made and see if this seemingly nostalgic fad is actually fashion forward.

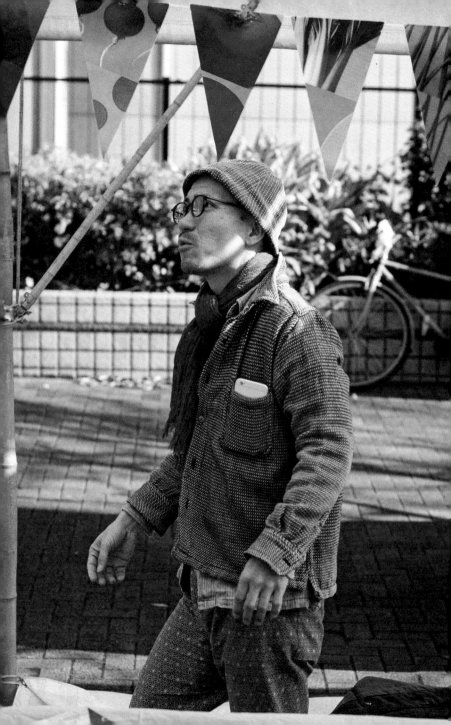

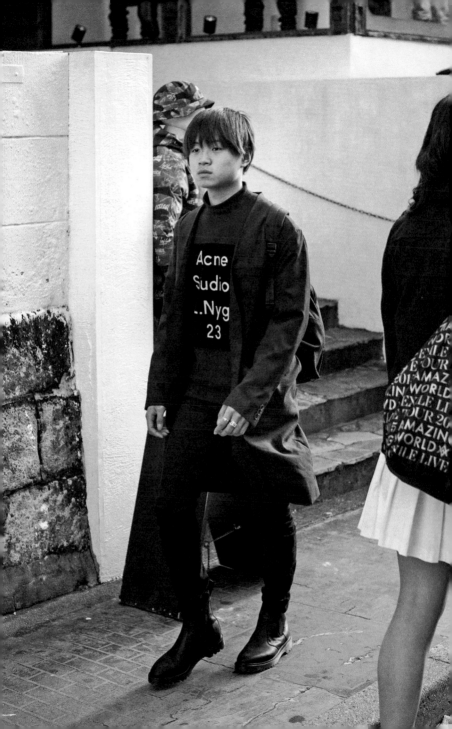

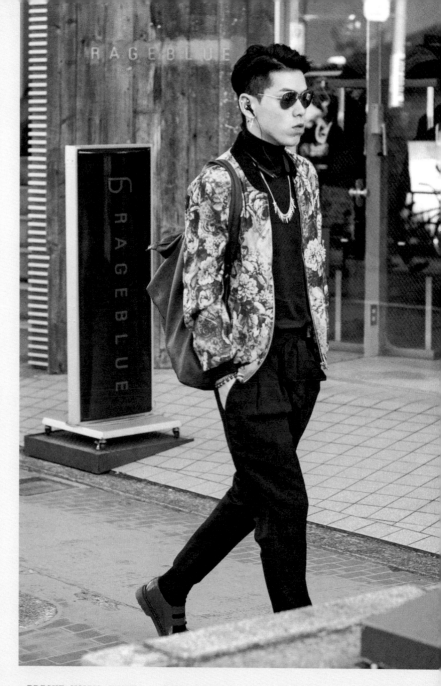

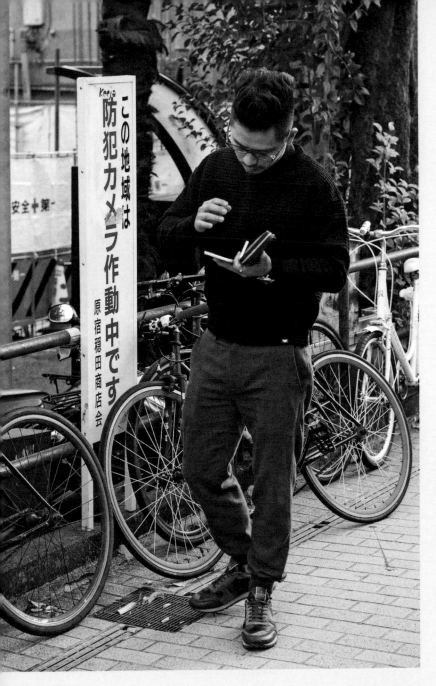

この地域は

防犯カメラ作動中です

原宿穏田商店会

Keep

安全中第一

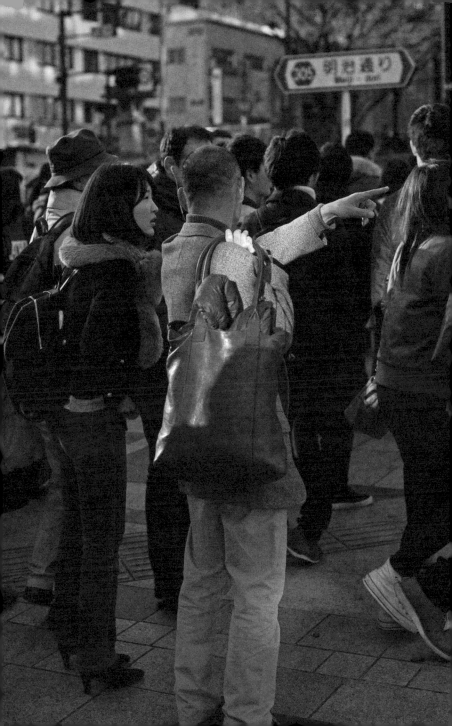

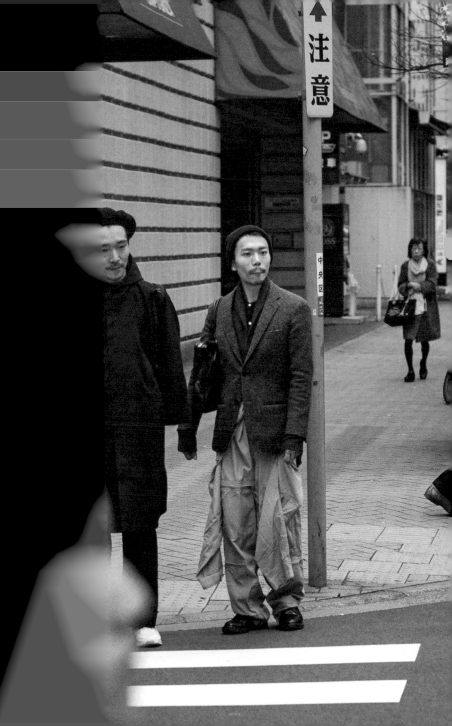

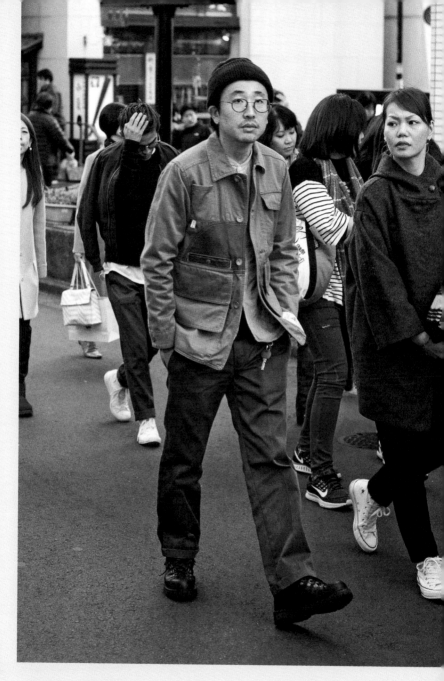

‹ DRAPED ⌃ UTILITY

175

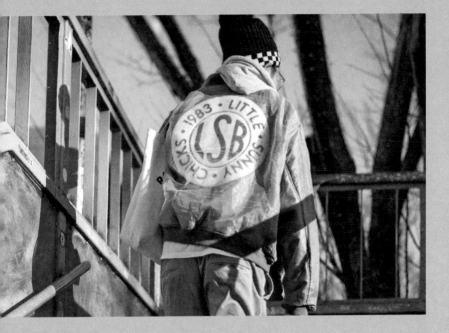

Americana influence, a staple on the streets of Tokyo.

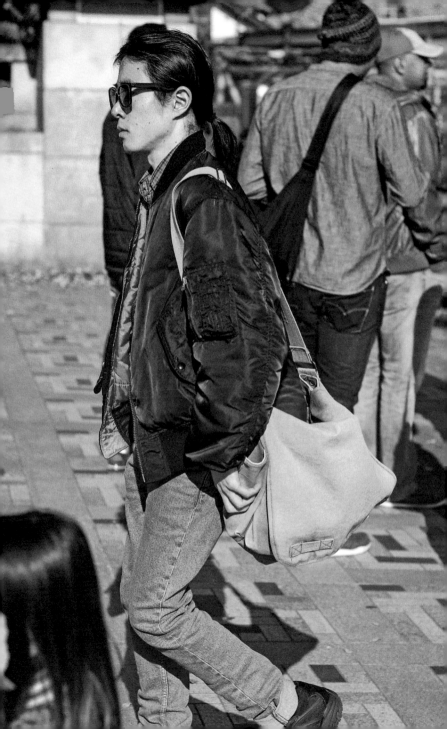

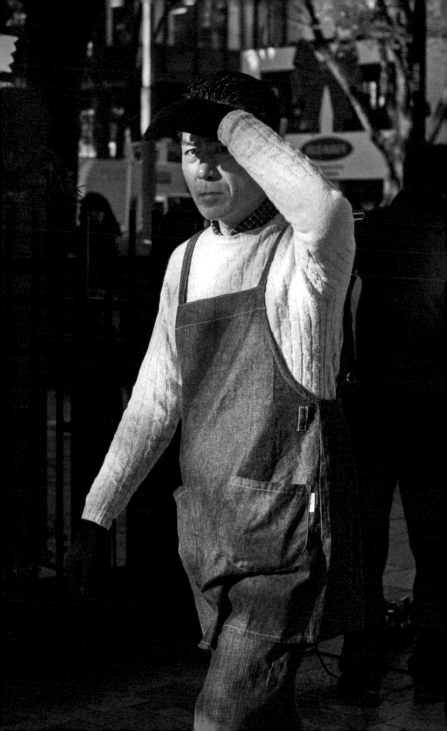

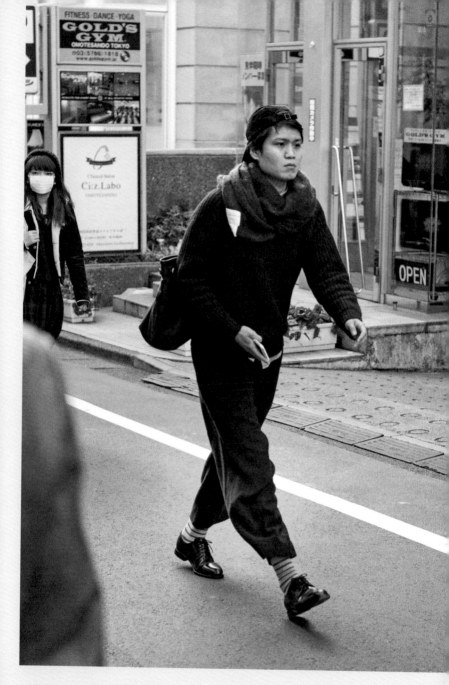

‹ DENIM WORKS ‹ BUNDLED

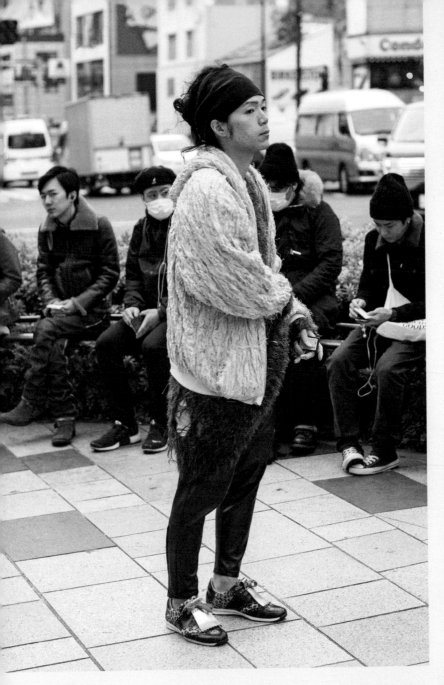

RAG AND BONE ^ PATCHED PATTERN >

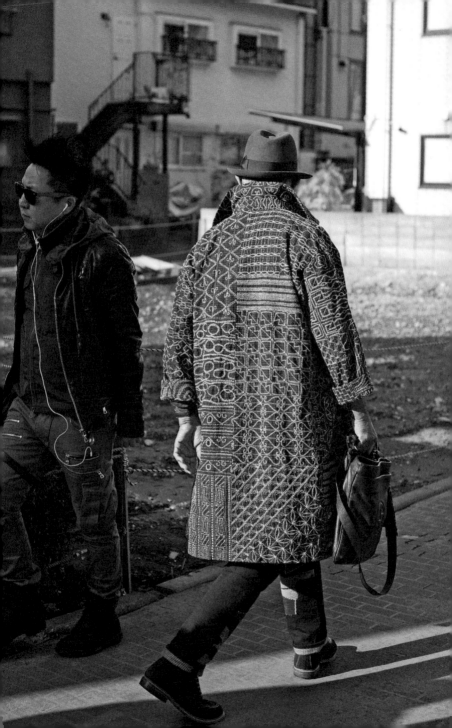

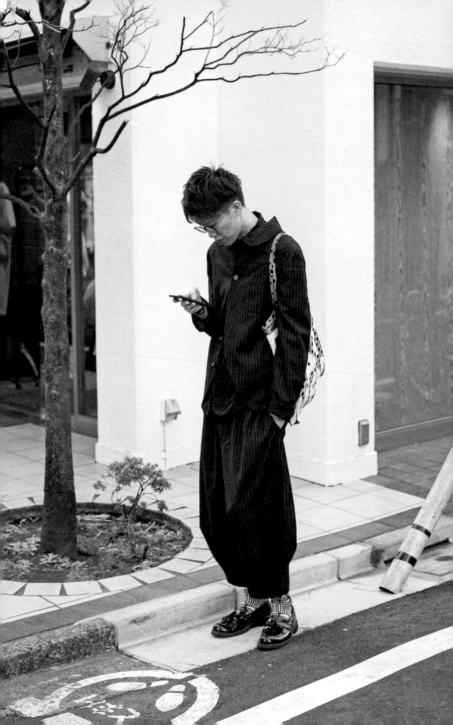

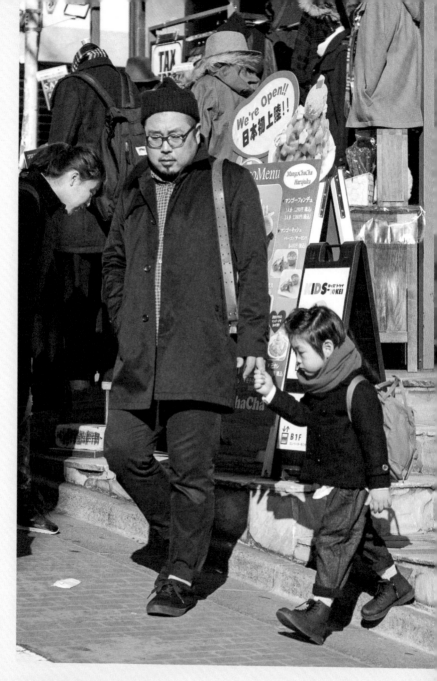

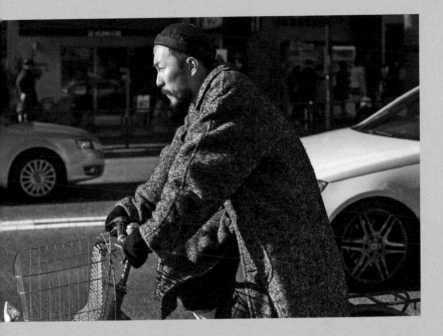

A classic mode of transport as the way of the future in Japan.

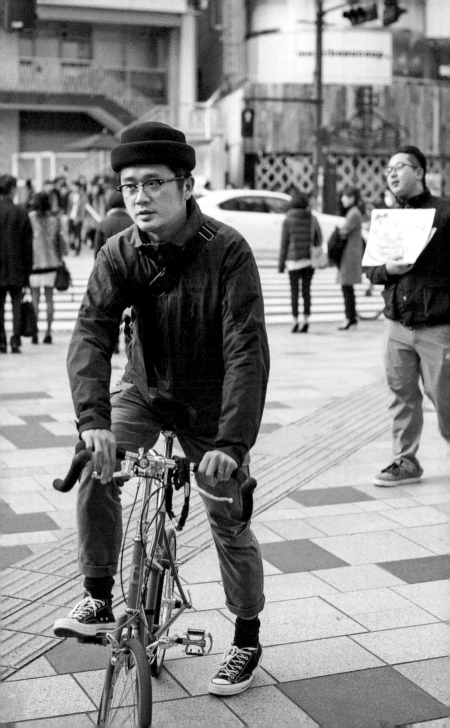

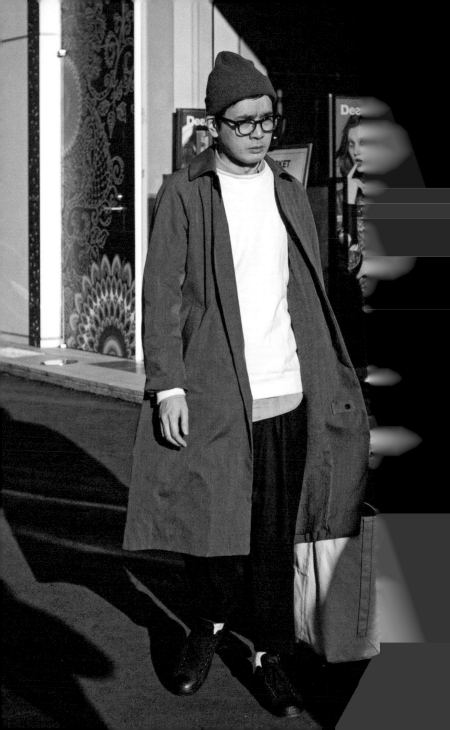

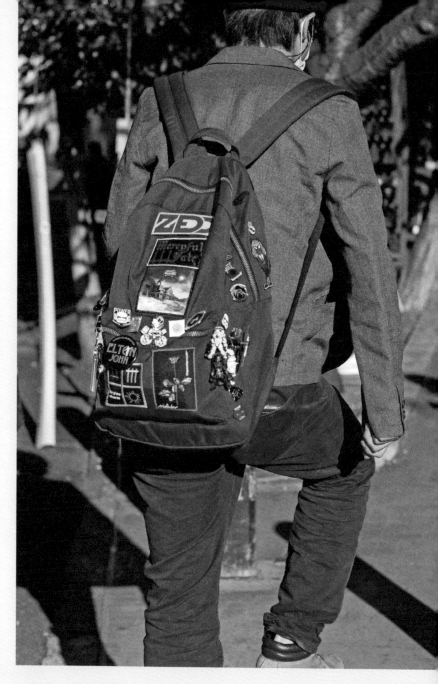

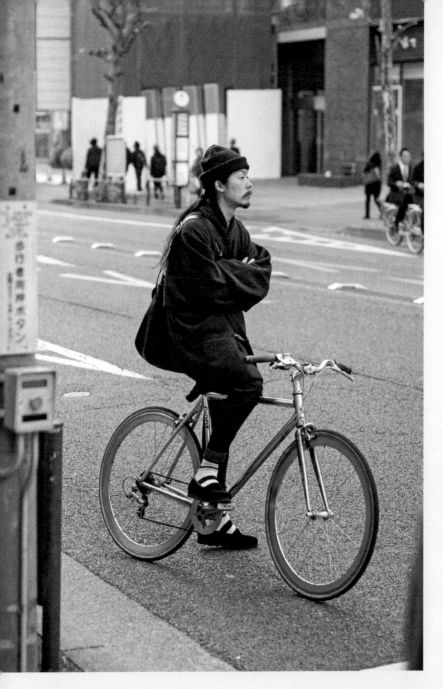

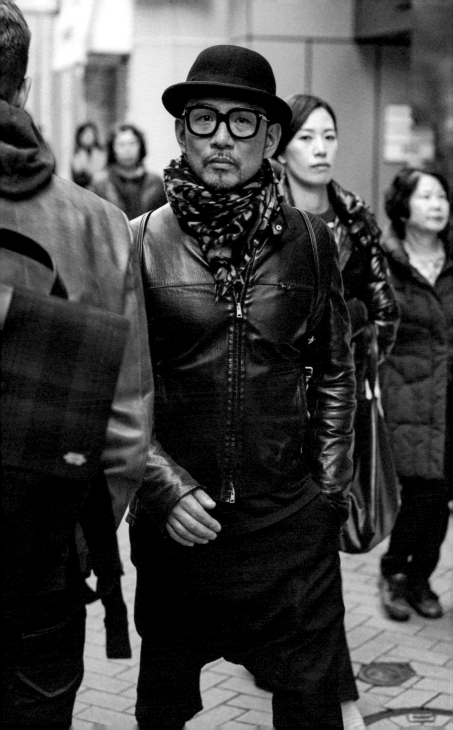

Two
Thousand
Sixteen

CHAPTER
NINE

TOWN
NEW YORK

BRIEF
NYFW:MEN'S

DATE
FEBRUARY 2016

Nature *Boy*

The new year brought on an appetite for a fashion week fix after a year away from the circuit. The Council of Fashion Designers of America introduced a dedicated menswear week in 2015, and I was eager to capture the fashion enthusiasts in their element. Thankfully, it was a milder winter this time around.

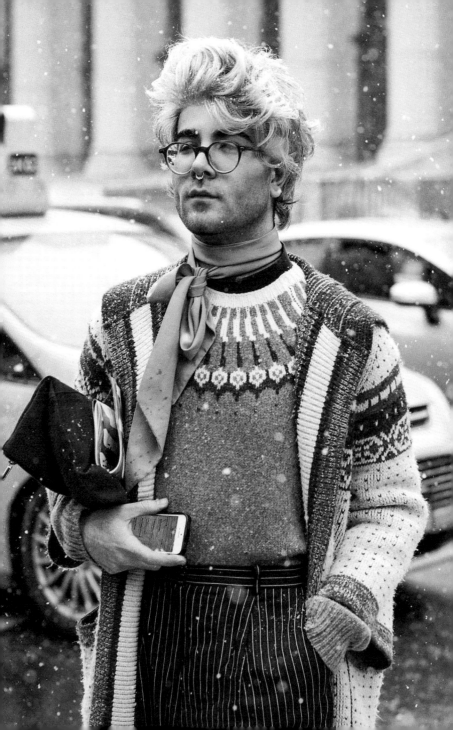

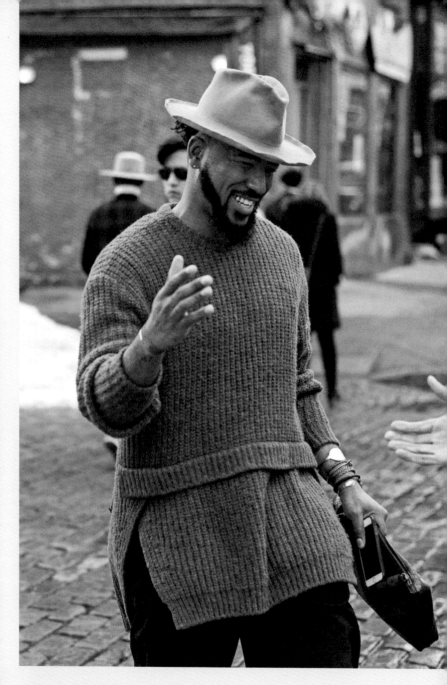

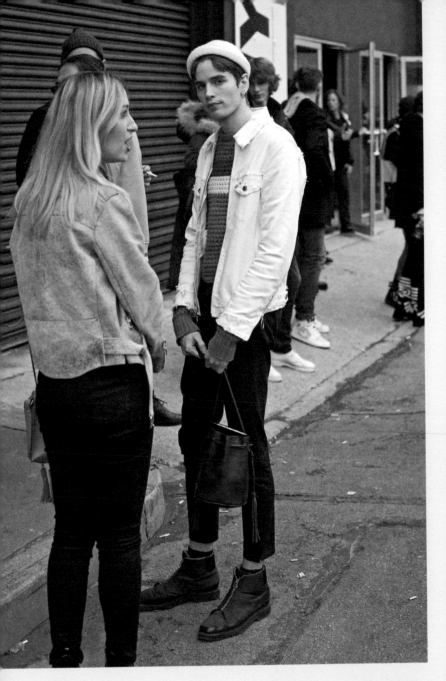

BUOYANCY ^ WINTER WHITE ›

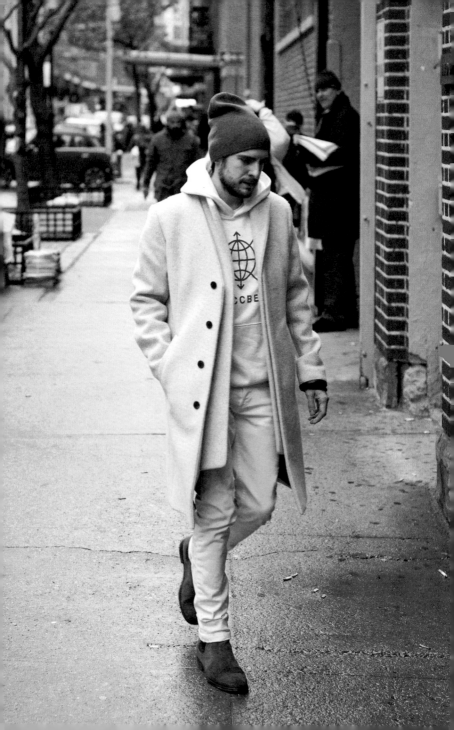

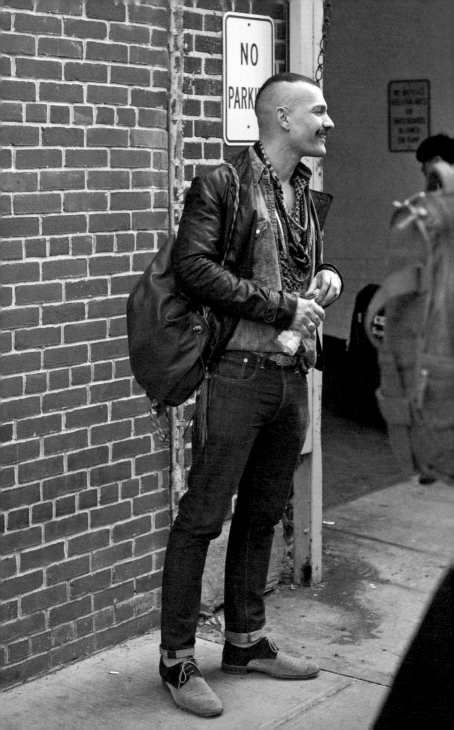

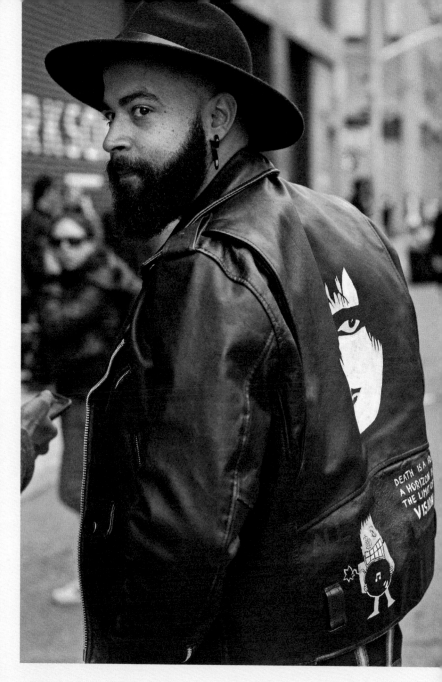

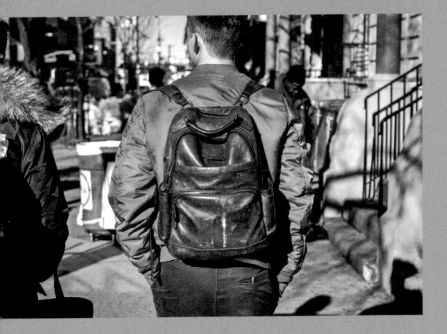

A good leather bag always catches my eye.

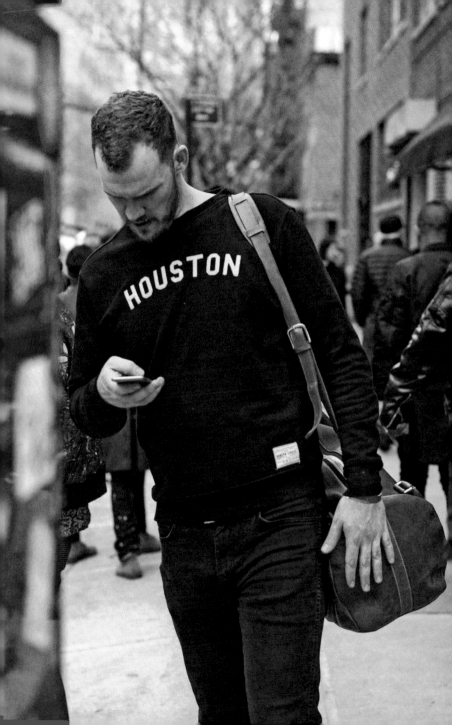

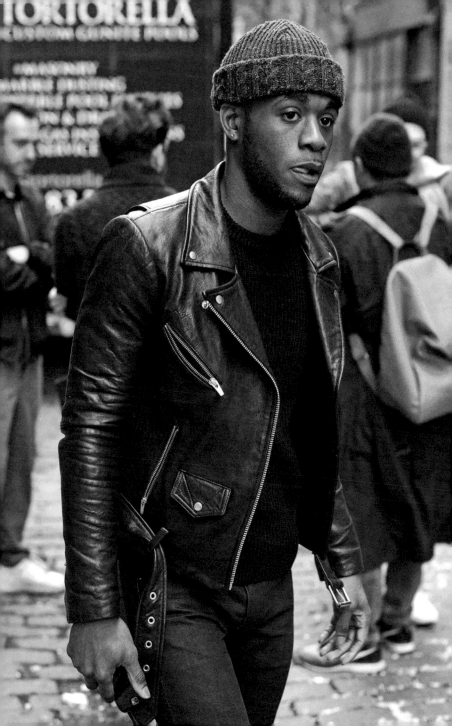

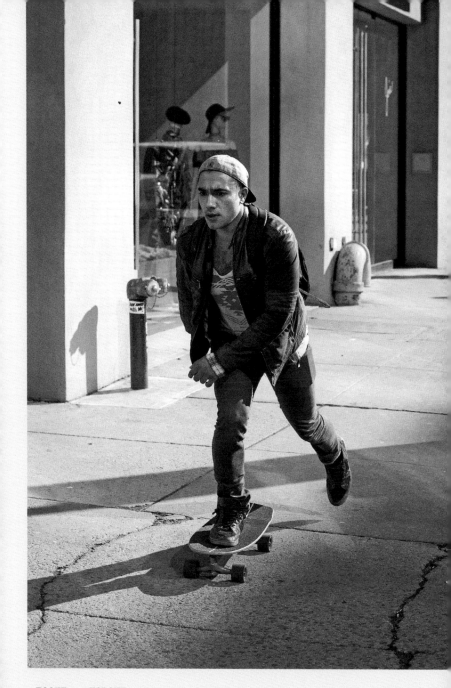

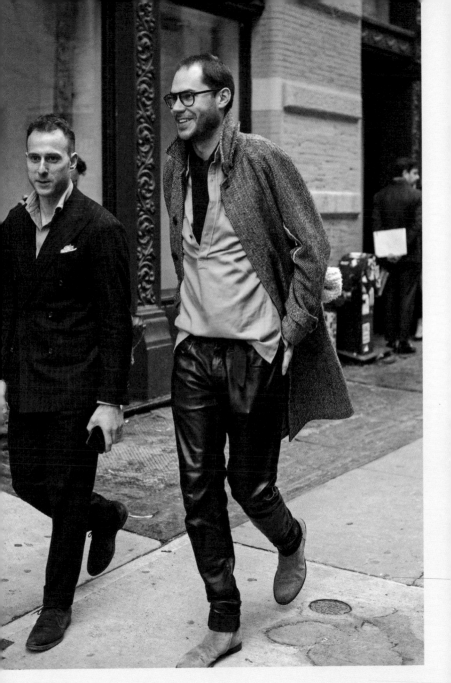

CHEVRON ˄ CHECK ˃

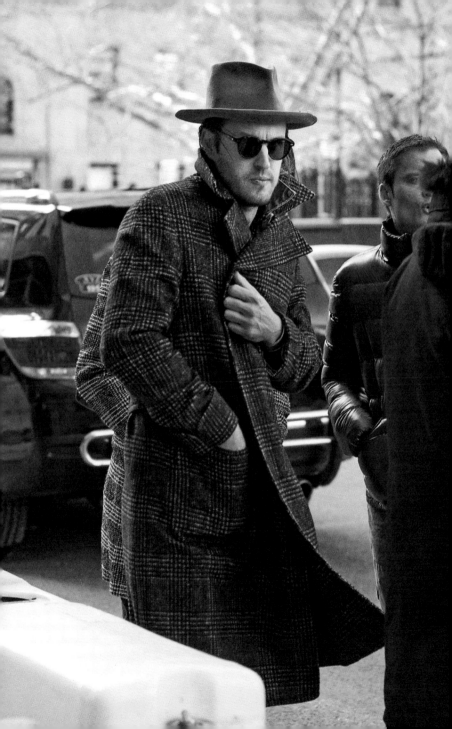

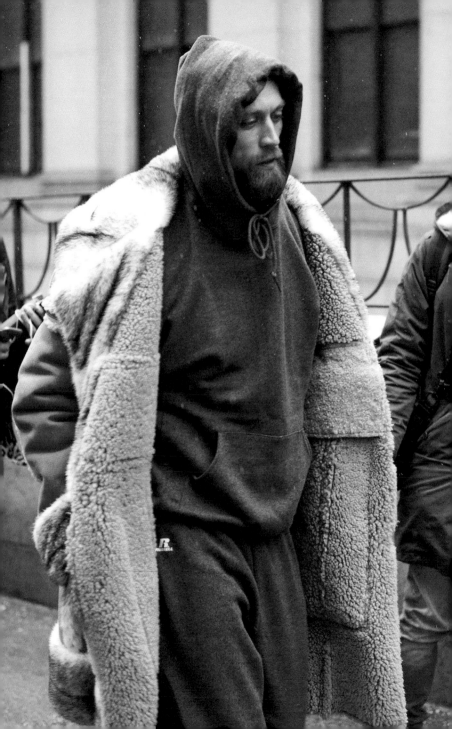

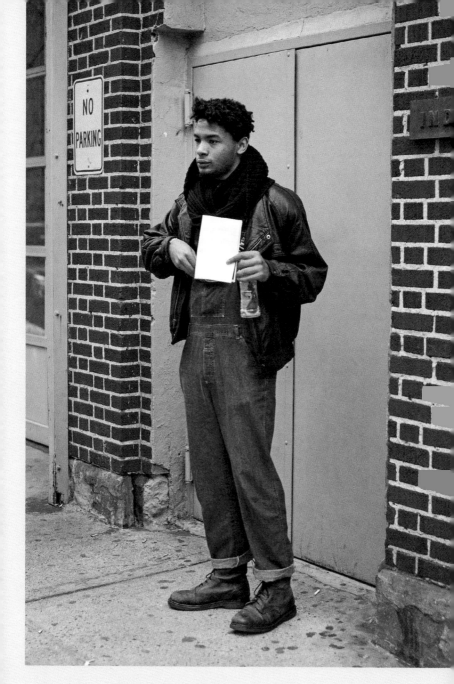

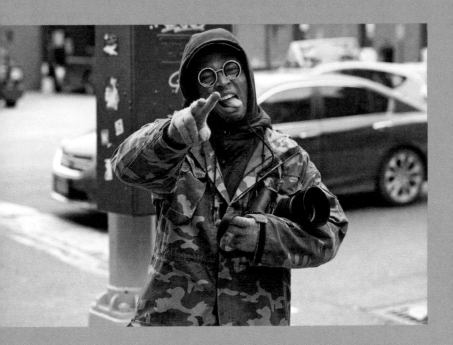

Fellow photographers
bring their A game
outside the shows.

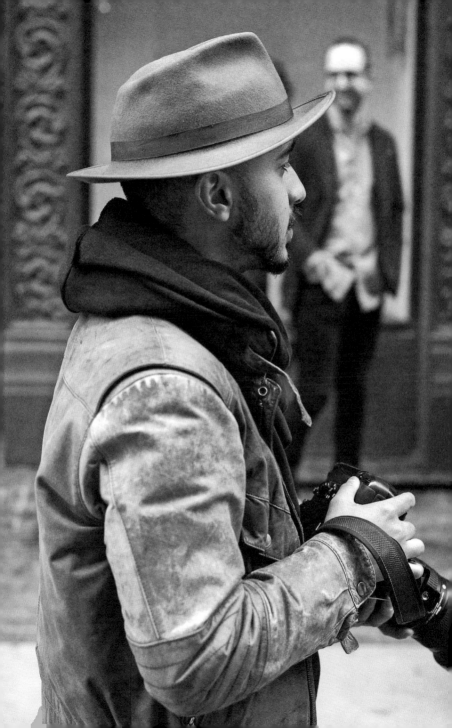

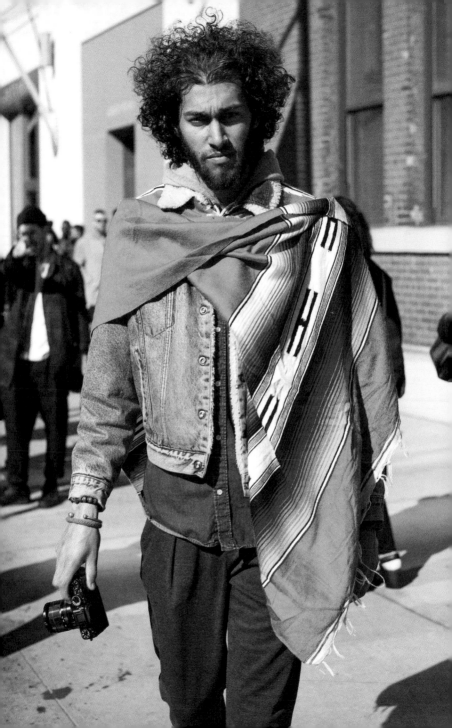

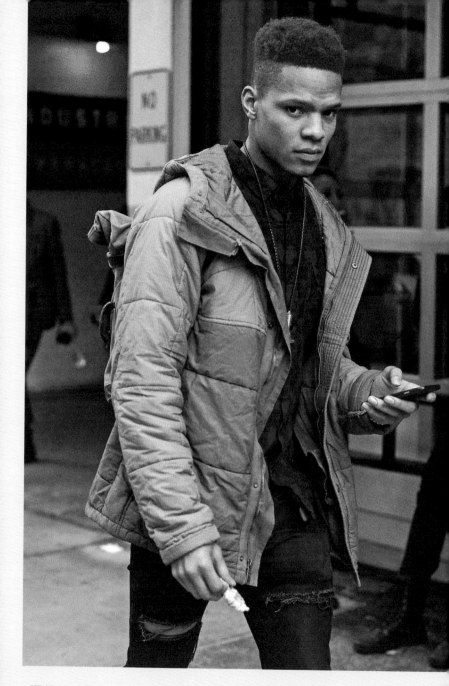

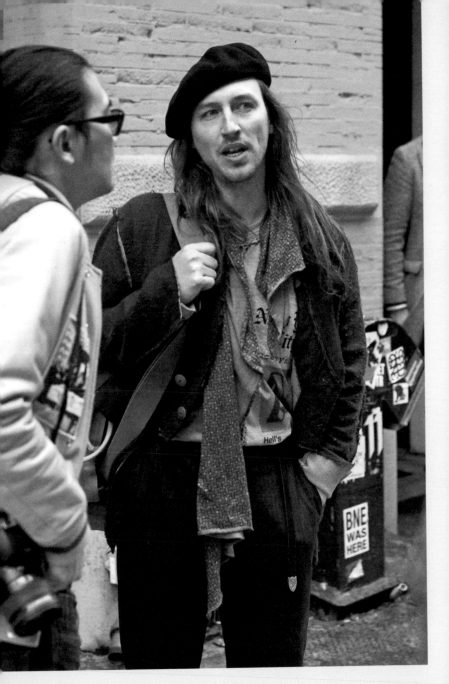

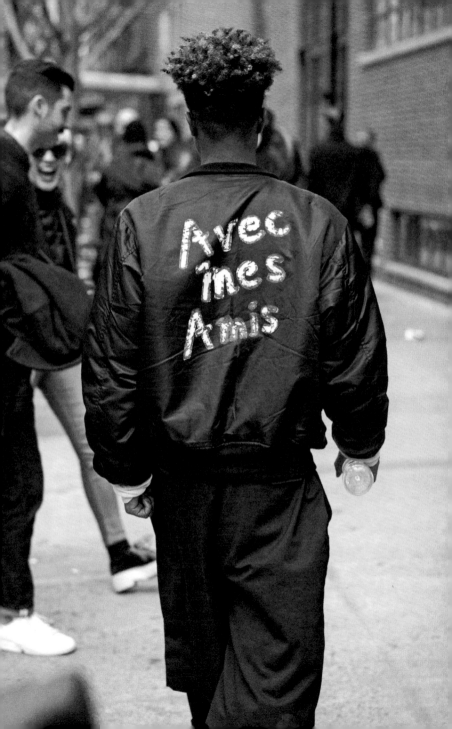

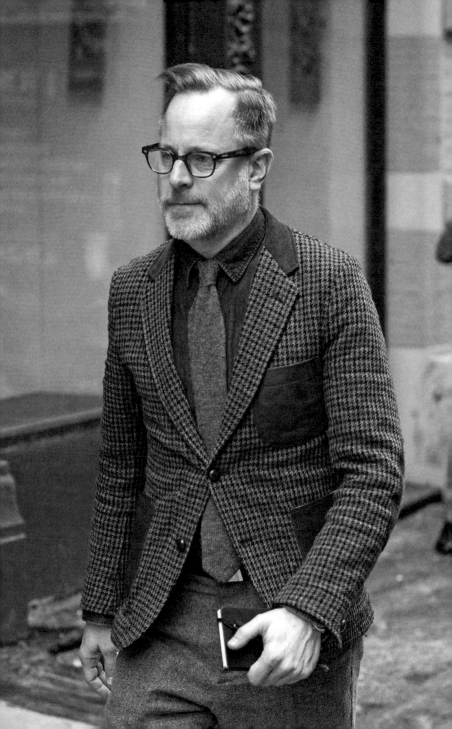

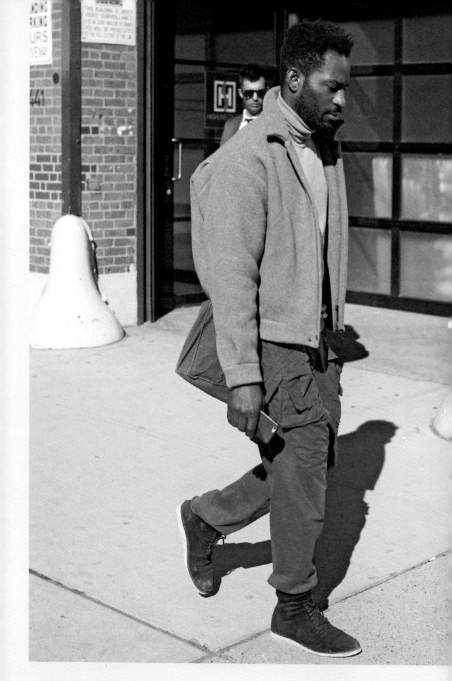

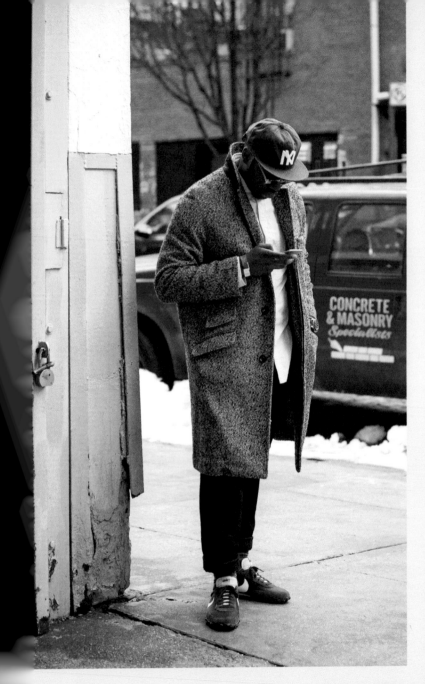

N.Y. BLUE ^ JAPANESE GREEN ›

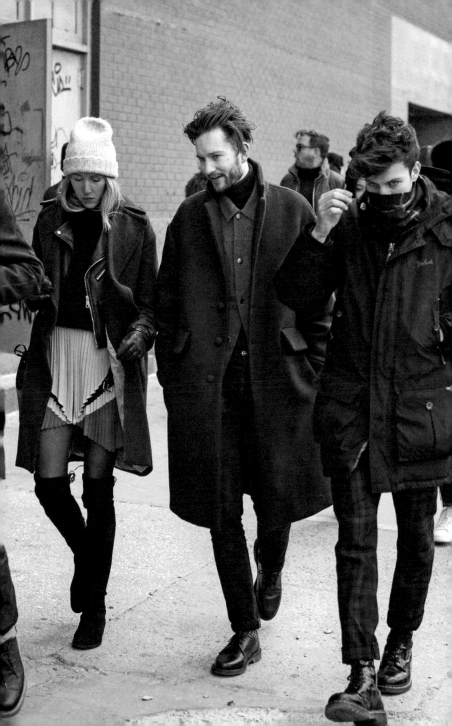

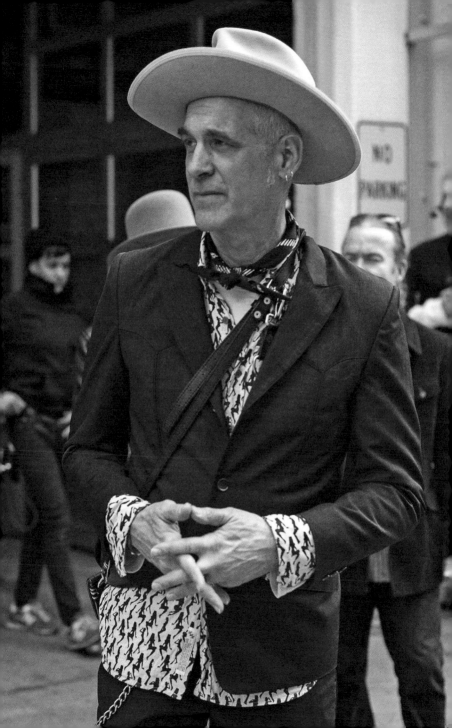

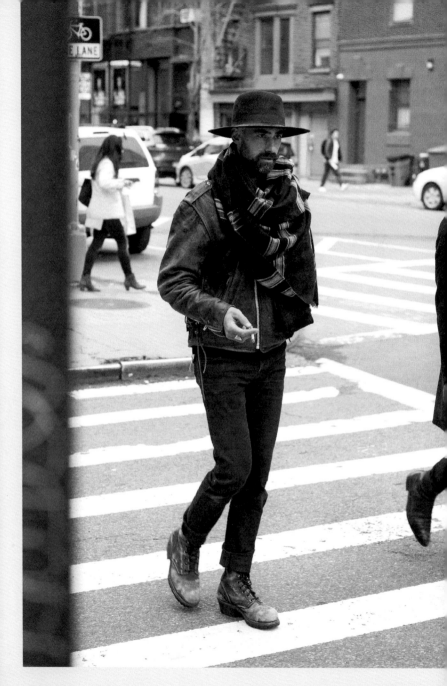

Easy *Living*

One of my favourite things about living in Sydney is the work–life balance. Sydneysiders have the persistence and hardworking mentality of residents of a metropolitan city, yet display the ease and carefree attitude of inhabitants of a small village in the Mediterranean.

The latter used to dictate the way the average man in Sydney dressed – singlet and shorts – everyday. Of course, I'm guilty of it myself, but if fashion week is anything to go by, the tide is turning…

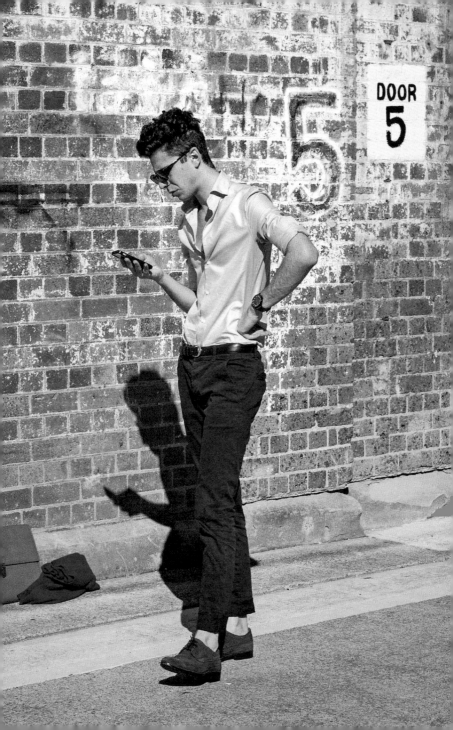

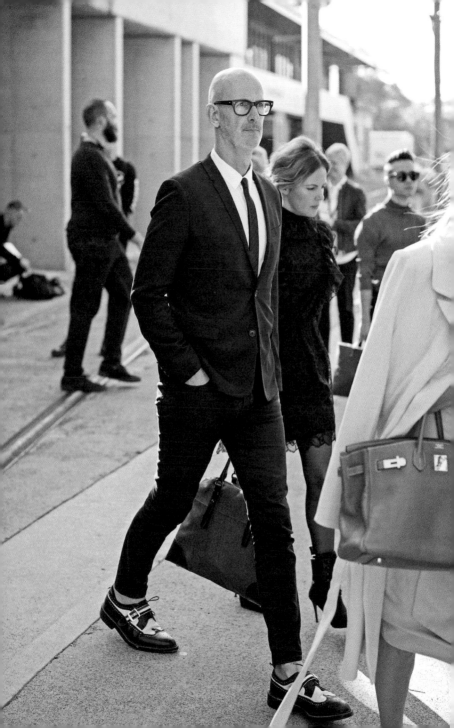

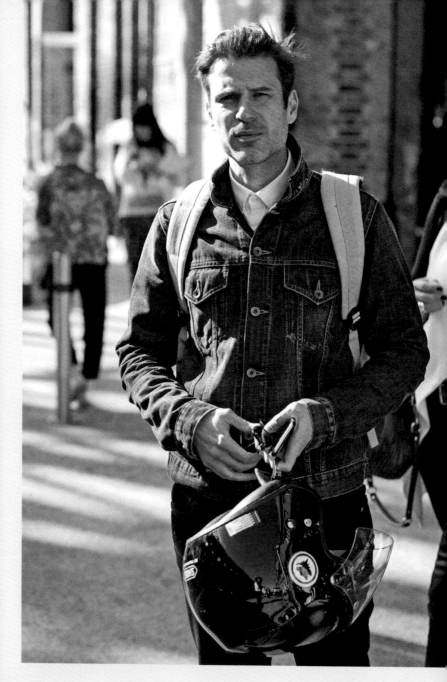

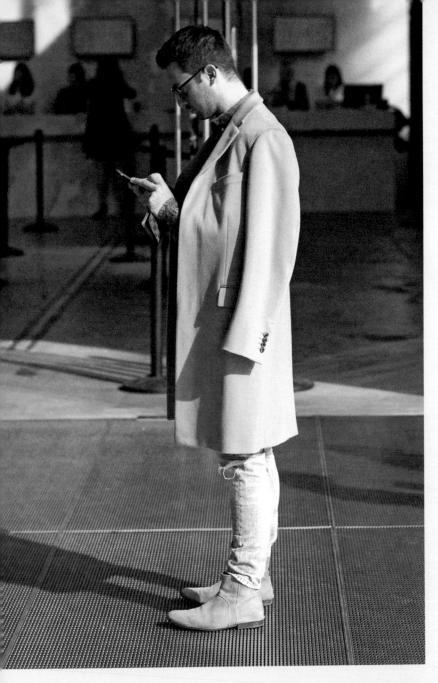

CAMEL ^ AMERICAN DENIM ›

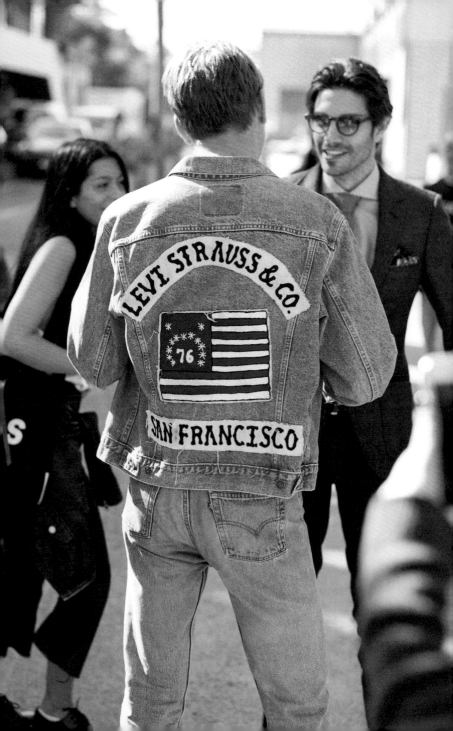

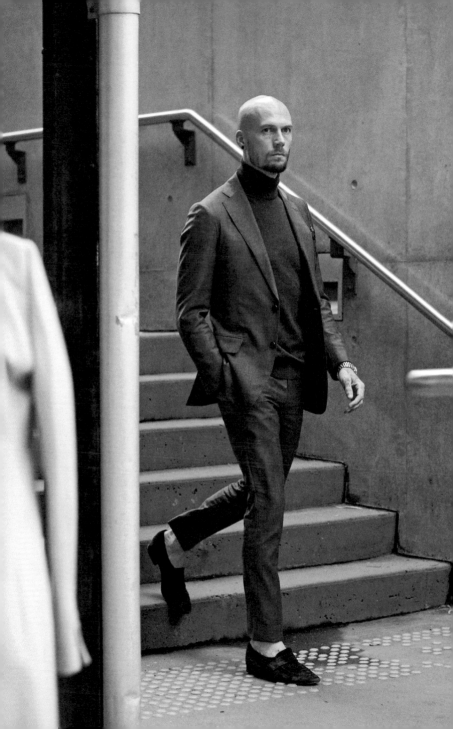

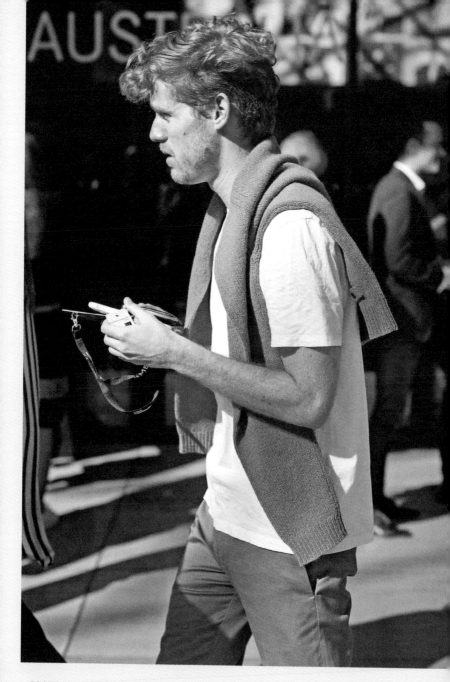

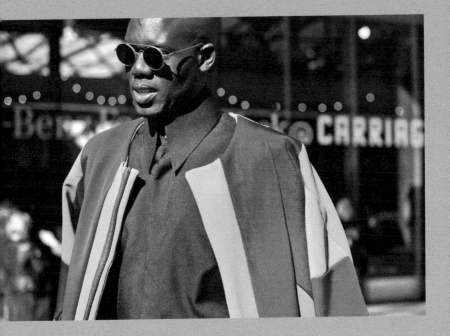

Contemporary cuts and colours are making their way on the streets of Sydney – previously mainly seen in Melbourne.

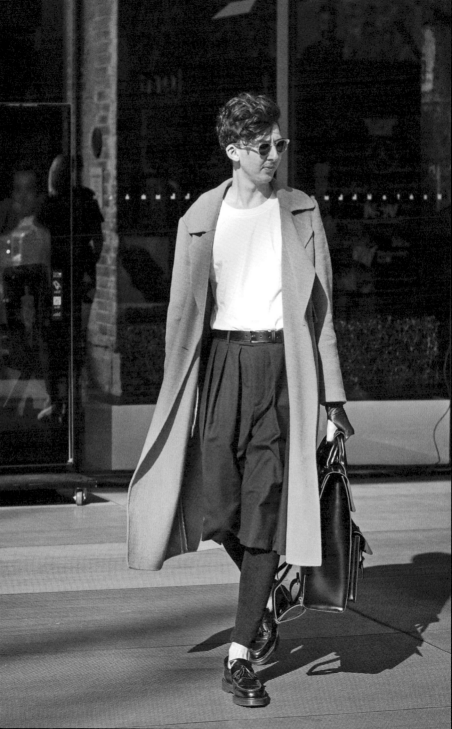

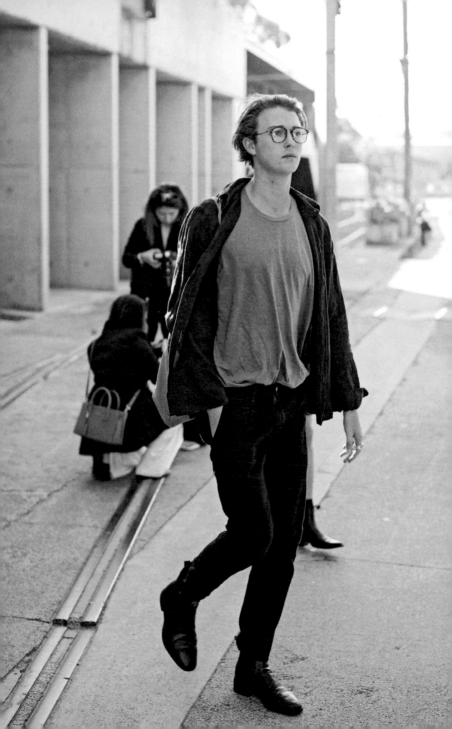

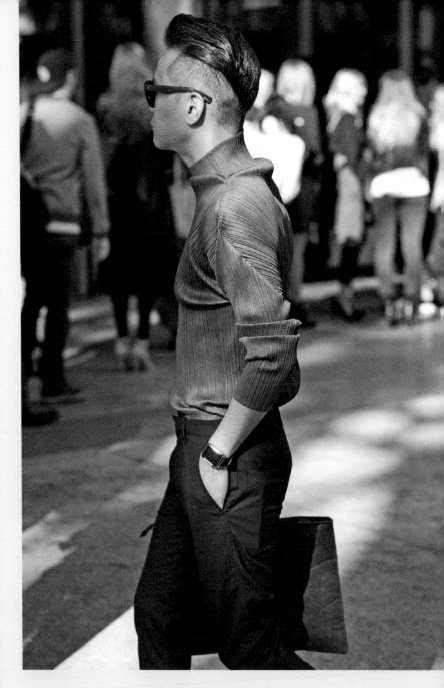

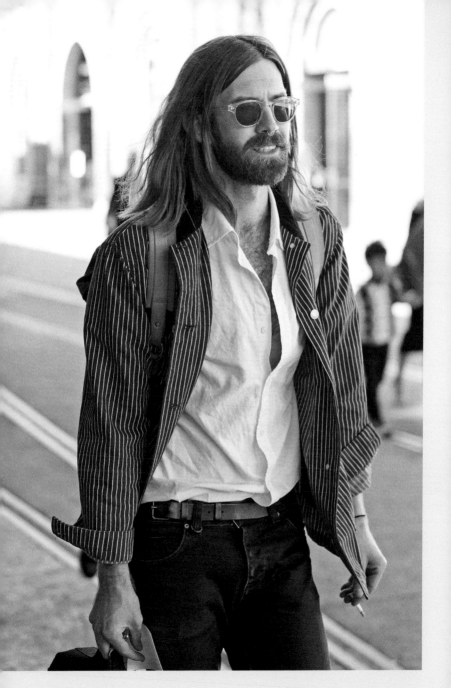

CANDY-STRIPER ^ TAG ›

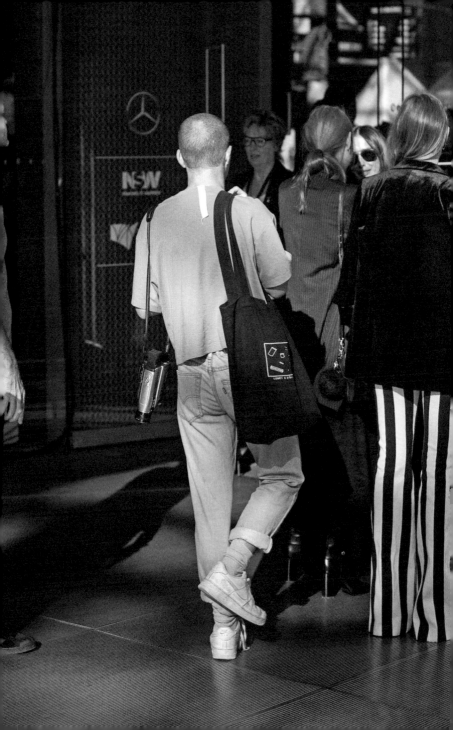

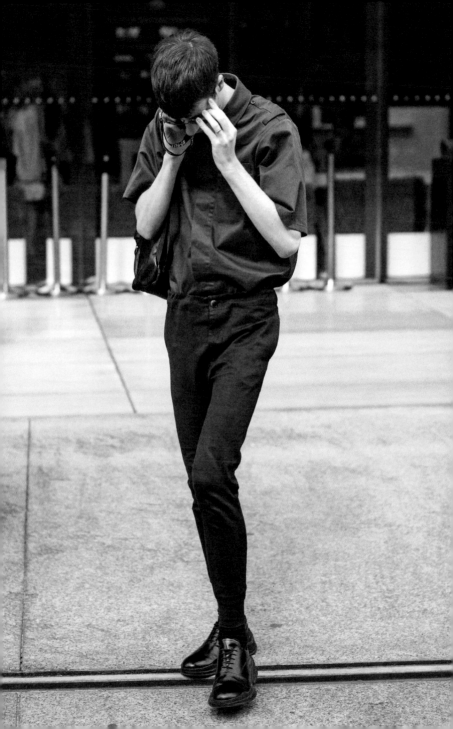

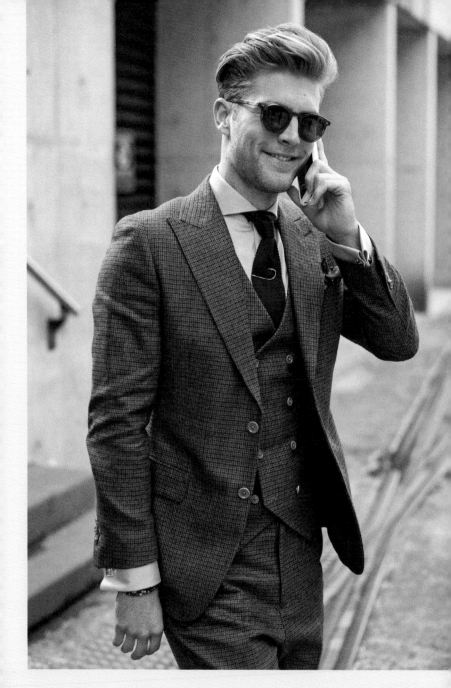

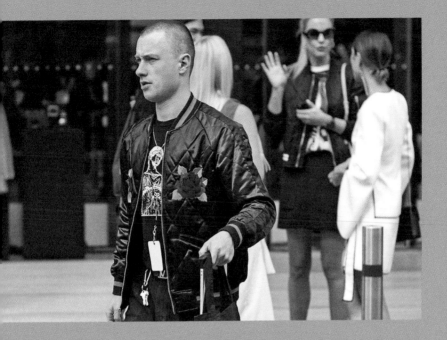

Vintage detailing from around the world.

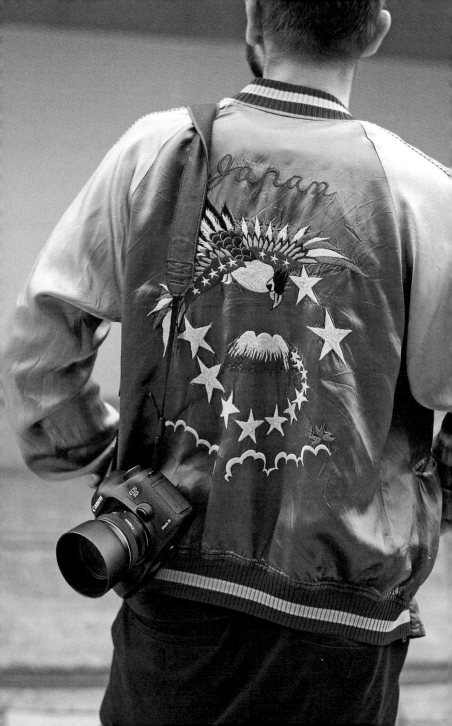

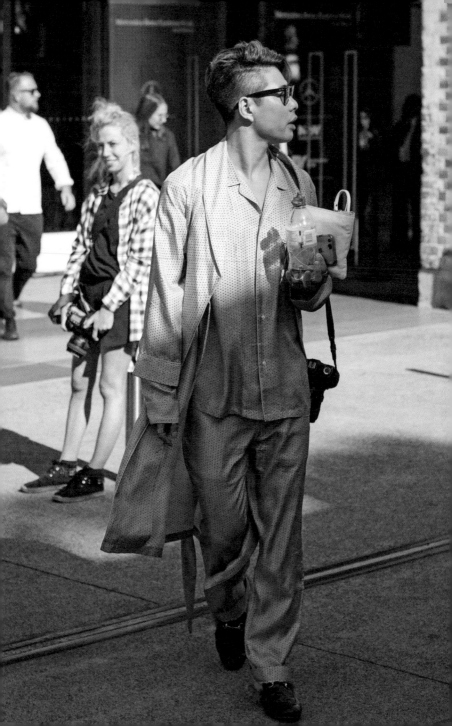

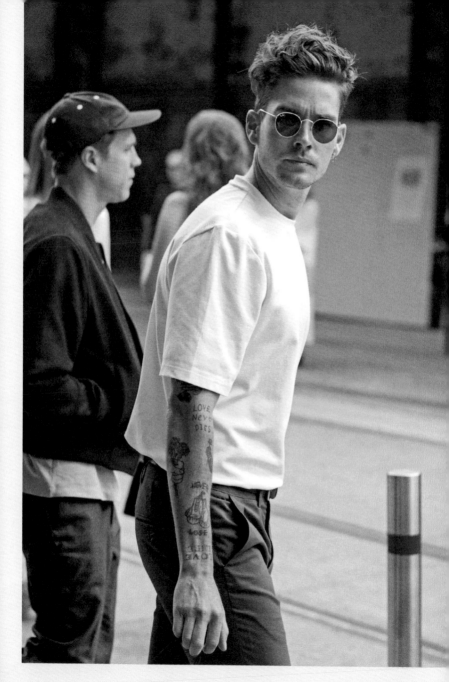

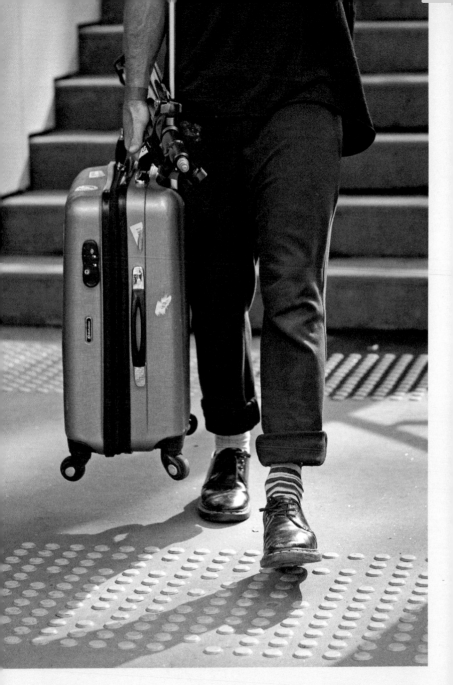

SOCKED ^ RIBBED ›

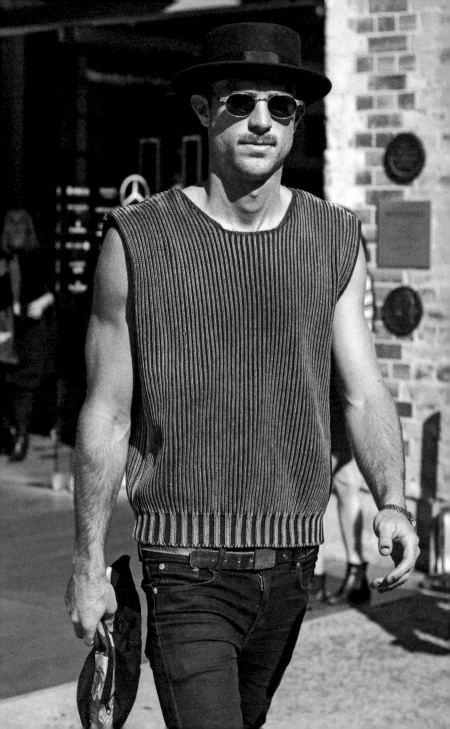

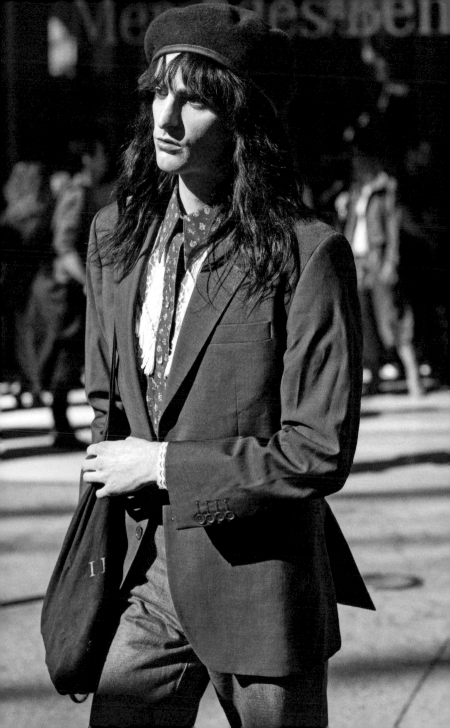

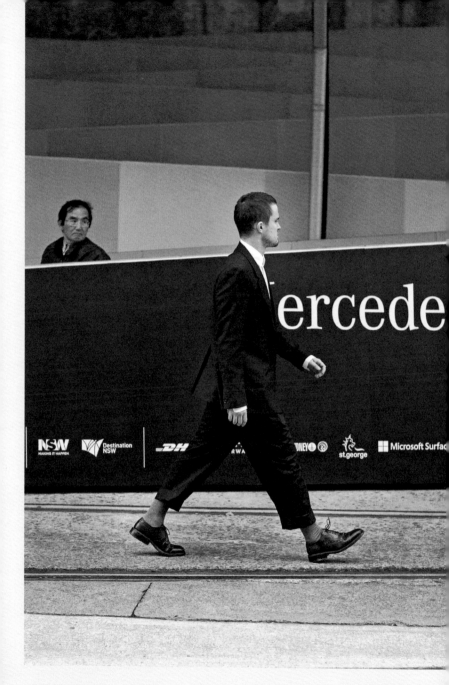

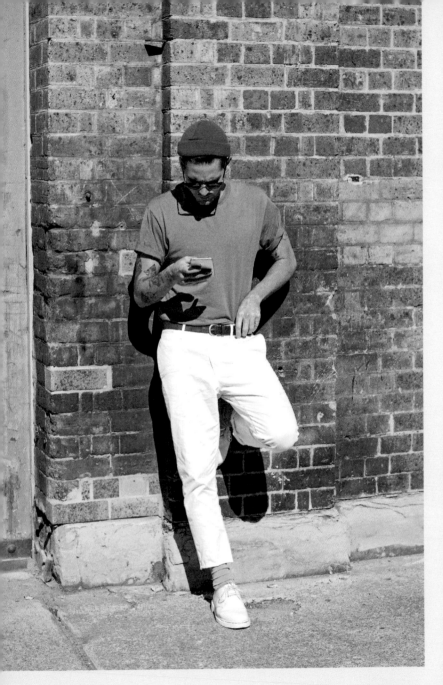

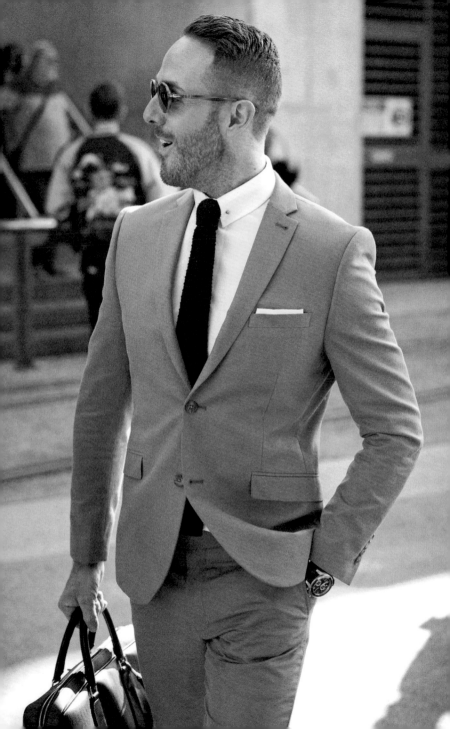

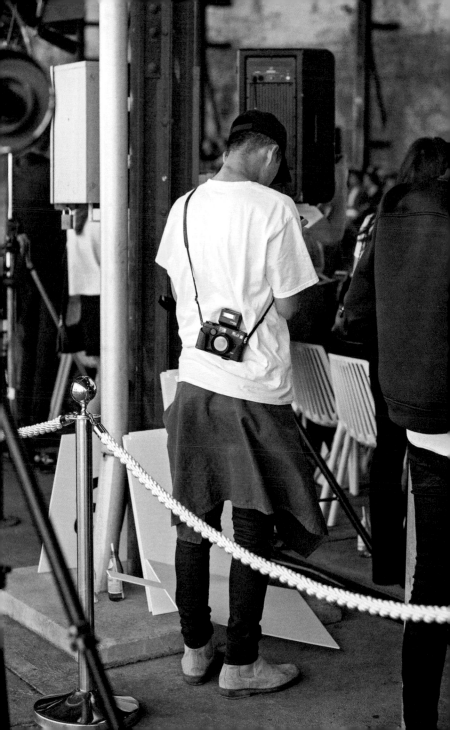

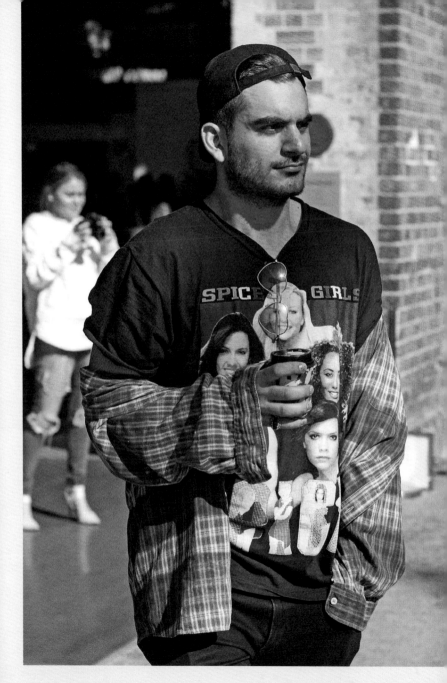

You Can't Go *Home Again*

In all the years that I've been shooting street style, I never photographed the streets of my hometown, Toronto. I guess you feel like you know everything about the places you grow up in and are less inspired to explore and discover new things.

As fate would have it, my brother and his wife had a baby in 2016, so I took it as an opportunity to meet my nephew Easton and revisit Toronto with my camera.

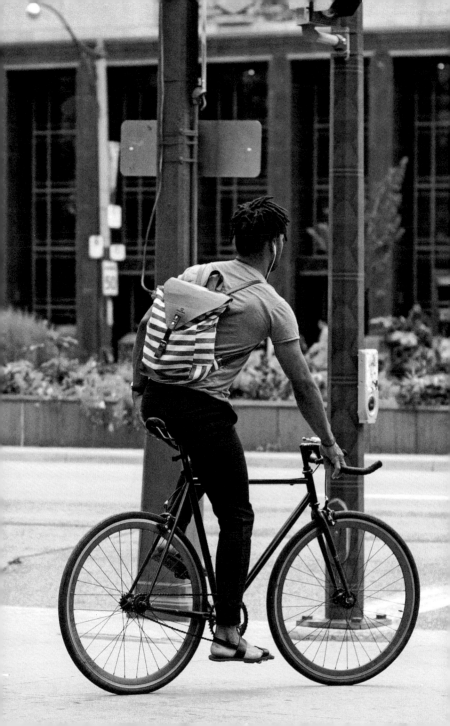

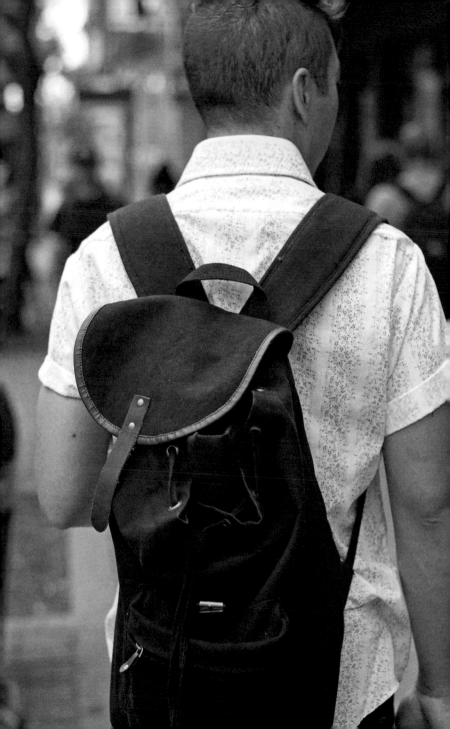

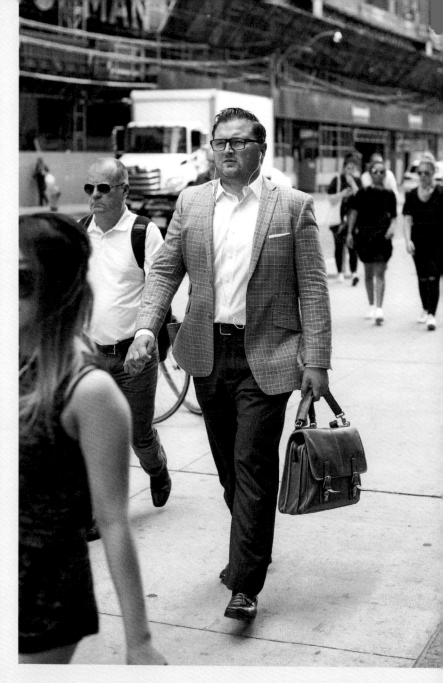

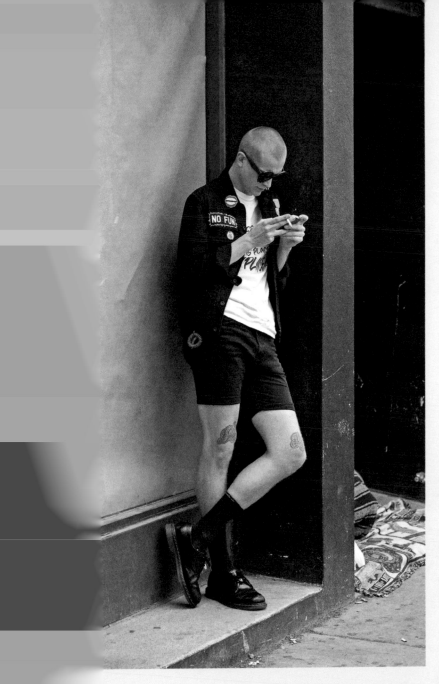

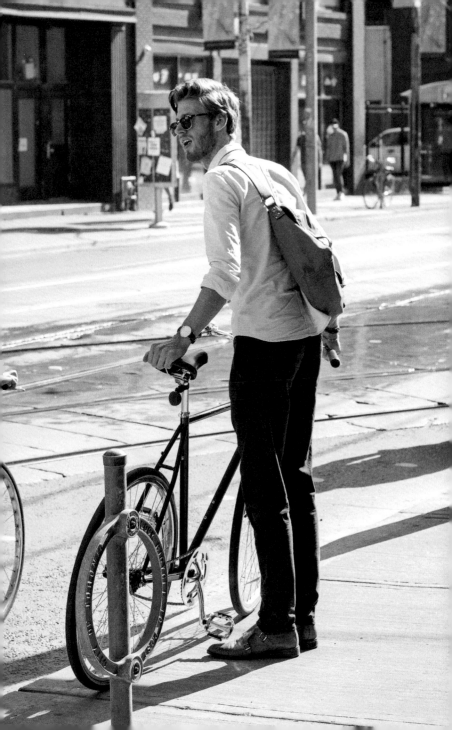

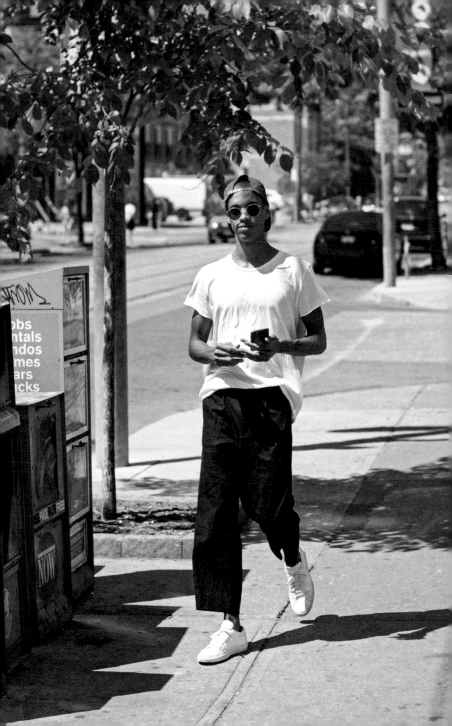

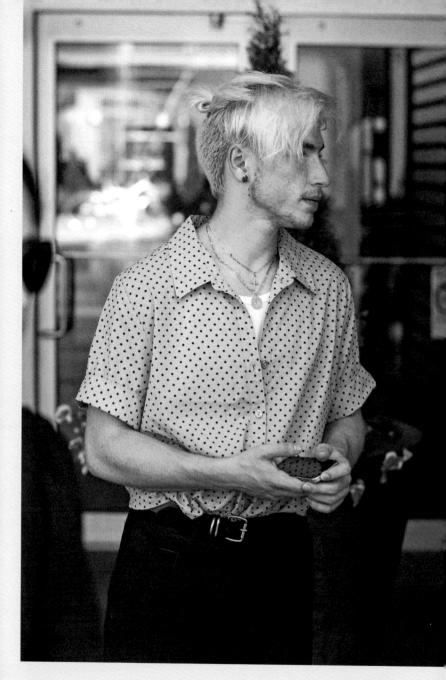

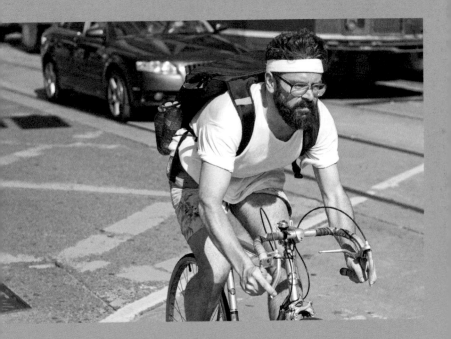

In a city in a state of redevelopment, cycling is the easiest mode of transport.

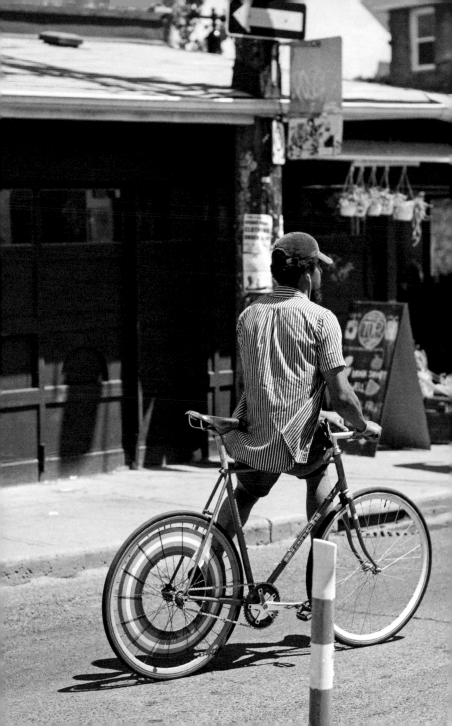

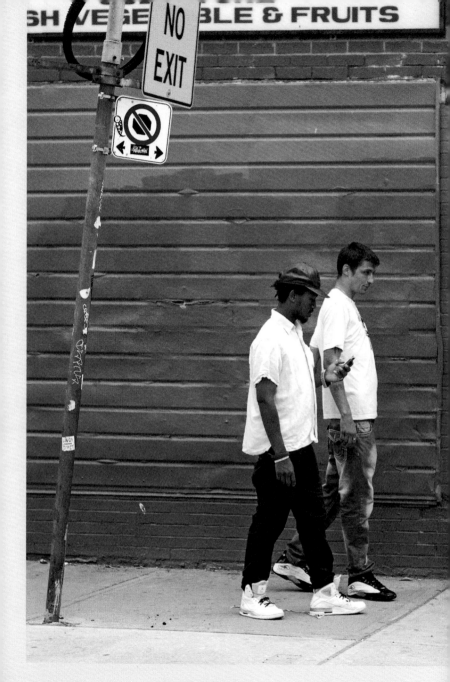

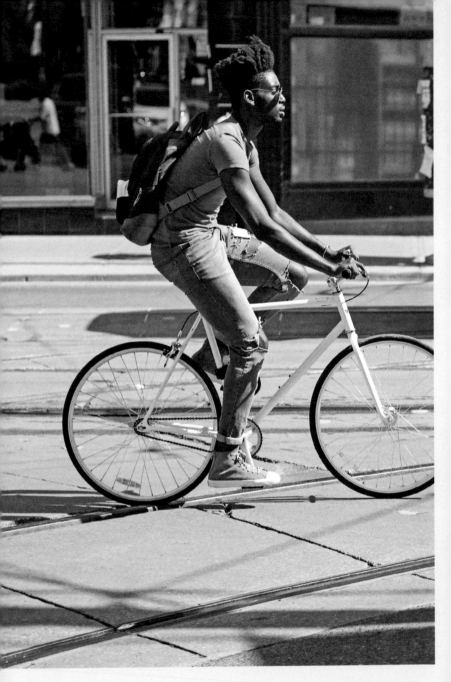

TIGHTROPE ˄ CORD ›

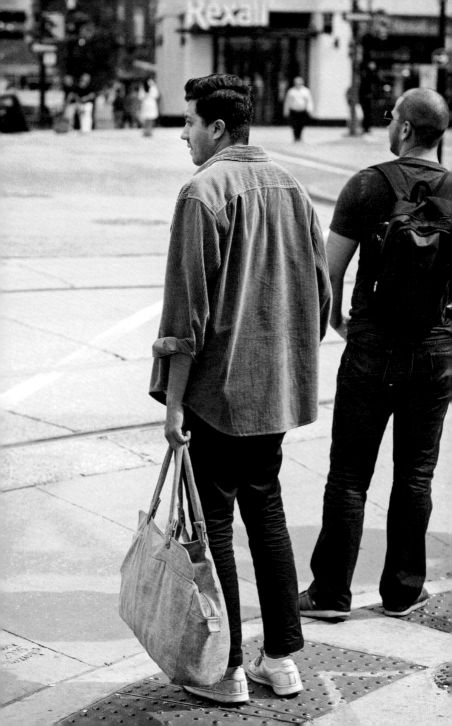

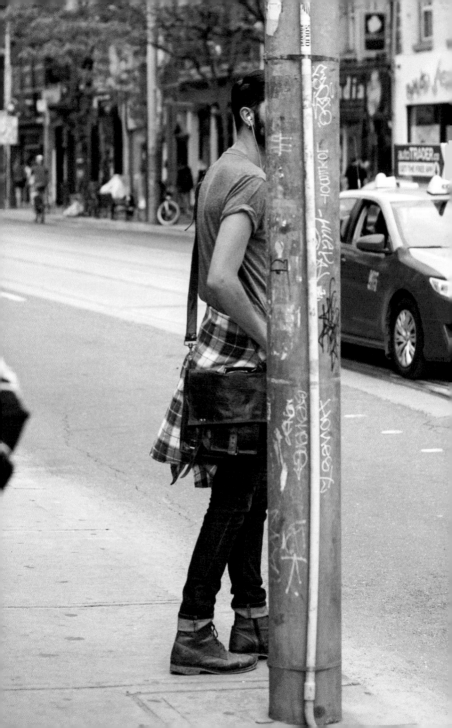

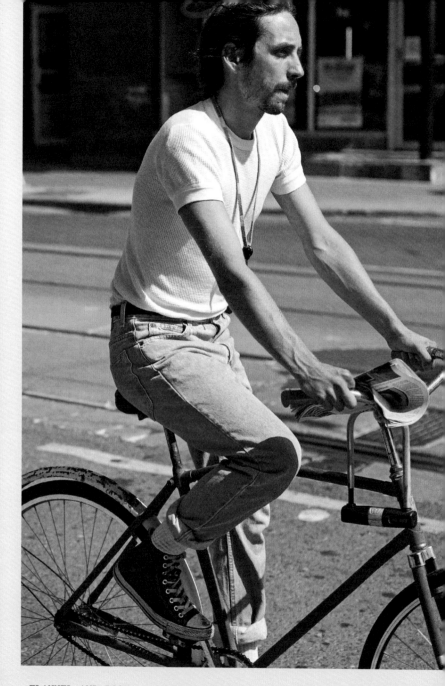

Young, scrappy
and hungry.

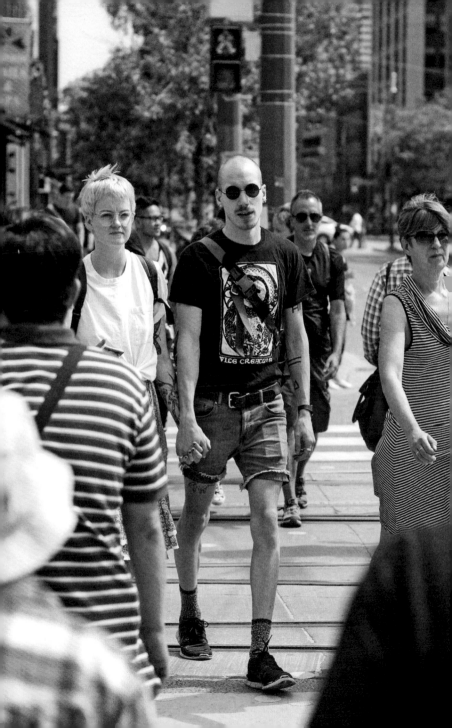

About the *Author*

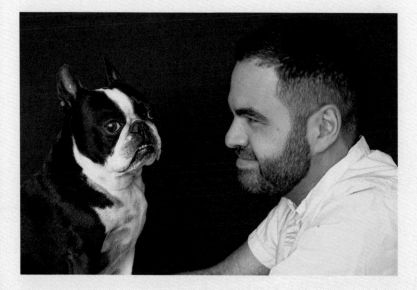

Giuseppe Santamaria is a photographer and editor, originally from Toronto, Canada. He moved to Sydney, Australia ten years ago and lives with his partner, Josh, and boston terrier, Baxter.

Follow his work at *meninthistown.com* and his life through pictures on Instagram @giuseppeinthistown.

More from *the series*

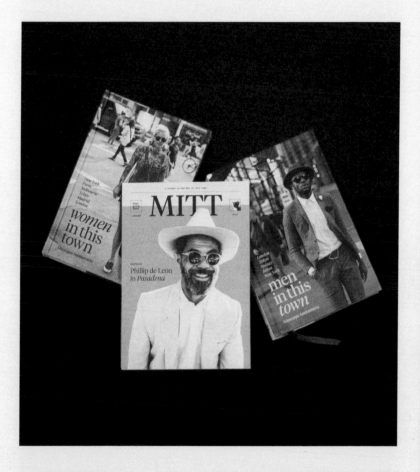

men in this town:
London, Tokyo, Sydney, Milan & New York

Photographer Giuseppe Santamaria brings together a unique photographic collection showcasing the street styles of the modern man from five distinct cities around the world – London, Tokyo, Sydney, Milan and New York. Alongside striking images captured from the streets, Giuseppe has profiled a handful of men from each city, exploring their particular approach to fashion and their sense of the menswear scene today.

women in this town:
New York, Paris, Melbourne, Tokyo, Madrid & London

In the follow up to *men in this town*, photographer, art director and fashion enthusiast Giuseppe Santamaria takes us to the streets of six incredible cities – New York, Paris, Melbourne, Tokyo, Madrid and London – to showcase the unique and stylish women that inhabit these towns. From classic elegance to menswear-inspired casual, a woman's dress style speaks volumes about her personality – and the city she inhabits. Featuring interviews with the everyday women whose distinctive styles cut a fine figure in the world of women's fashion.

MITT magazine

Based on the men's street style blog *men in this town*, *MITT* is a printed quarterly digest capturing the everyday man in his natural habitat. Through profiles, interviews, features and photo essays, *MITT* takes a closer look at who the men on the street are and their particular approach to the many facets of life.

Thank *you*

To Josh, for being a FaceTime away when we were thousands of miles apart. I love you.

To my mom, my dad and the rest of my loving family back home in Canada, thank you for your never-ending encouragement. And to Dom for making me feel a little less alone in my travels.

To Hardie Grant for helping me bring my online projects to life in the printed form.

And to my little man, Baxter, the most beautiful subject I've photographed.

Published in 2017 by Hardie Grant Books,
an imprint of Hardie Grant Publishing

Hardie Grant Books (Melbourne)
Building 1, 658 Church Street
Richmond, Victoria 3121
hardiegrantbooks.com.au

Hardie Grant Books (London)
5th & 6th Floors
52–54 Southwark Street
London SE1 1UN
hardiegrantbooks.co.uk

A Cataloguing-in-Publication entry is available from the
National Library of Australia at www.nla.gov.au

Alone In A Crowd
ISBN 978 1 74379 273 5

Publishing Director: Jane Willson
Managing Editor: Marg Bowman
Project Editor: Anna Collett
Design Manager: Mark Campbell
Production Manager: Todd Rechner
Production Coordinator: Rebecca Bryson

Colour reproduction by Splitting Image Colour Studio
Printed in China by 1010 Printing International Limited